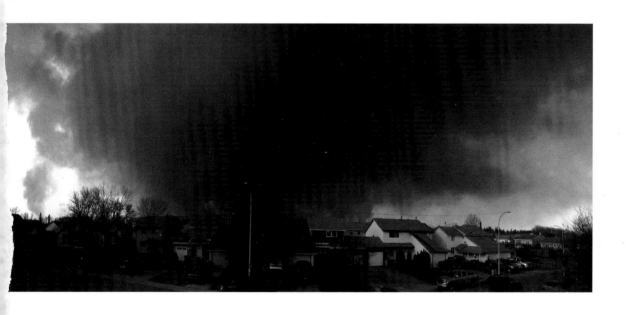

INTO THE FIRE

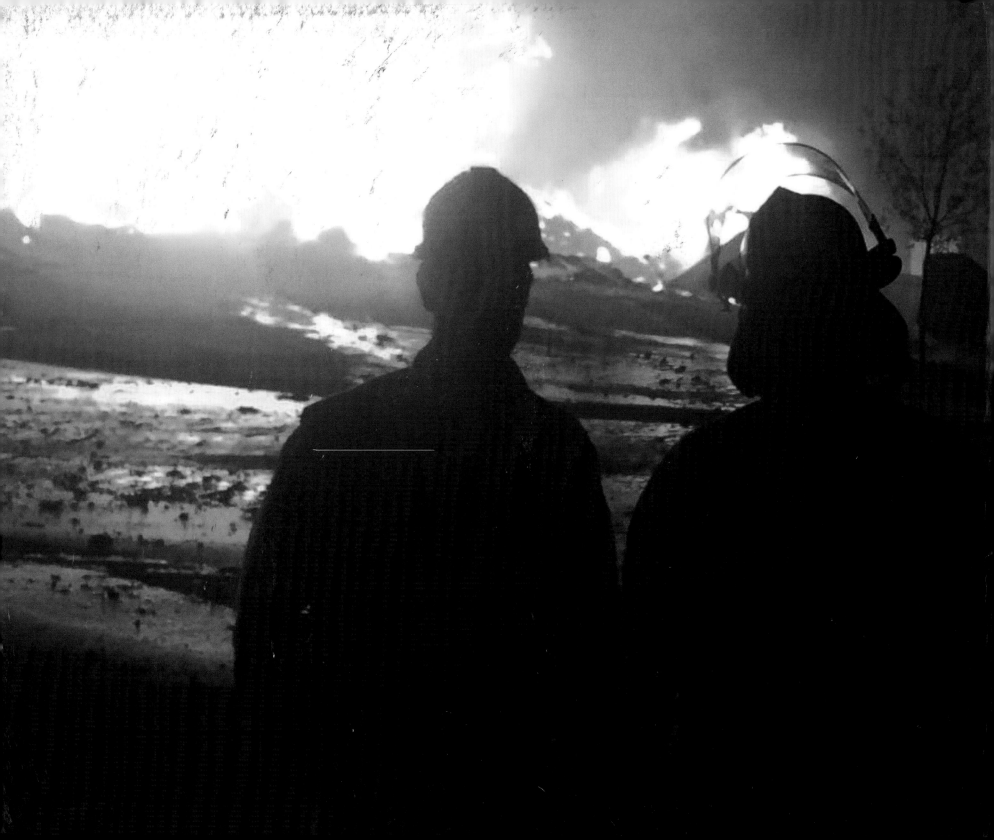

INTO THE FIRE

Library and Archives Canada Cataloguing in Publication is available upon request

ISBN: 978-0-7710-3928-7
ebook ISBN: 978-0-7710-3929-4

Jacket images: Troy Palmer
Book design by Jennifer Lum

Printed and bound in Canada

McClelland & Stewart,
a division of Penguin Random House Canada Limited,
a Penguin Random House Company
www.penguinrandomhouse.ca

1 2 3 4 5 21 20 19 18 17

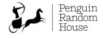
Penguin
Random
House

CONTENTS

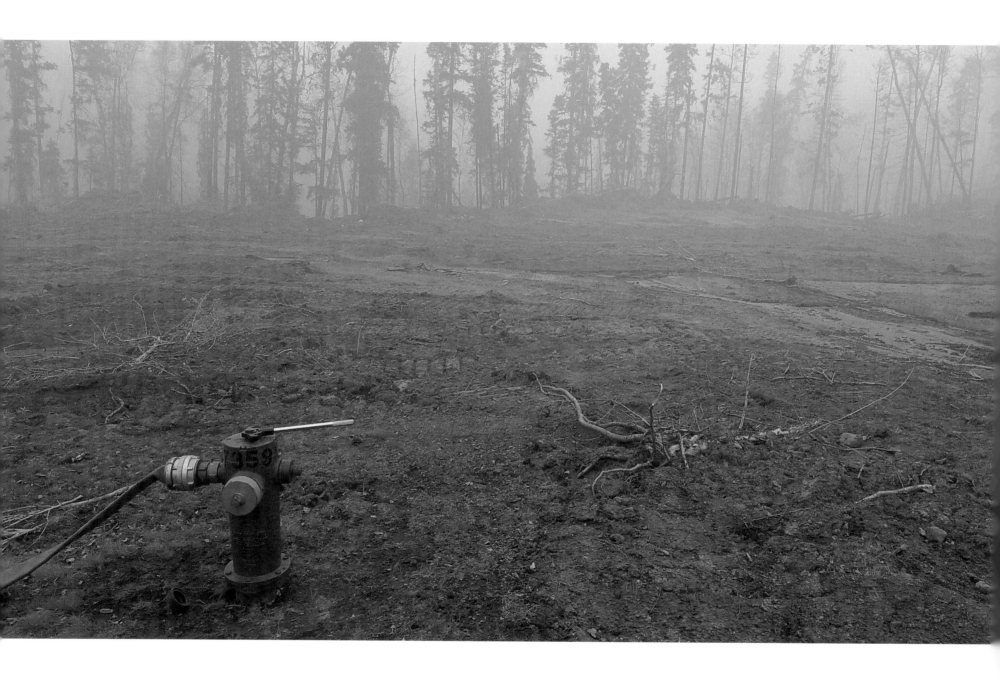

The Fort McMurray wildfires of May 2016 were one of the biggest natural disasters in recent Canadian history. The ensuing evacuations during that historic week in May were on an unprecedented scale. Ninety thousand people were evacuated from the city, and for thousands, it would be the last time they would see their homes, neighbourhoods, or even Fort McMurray, again. Ninety thousand incredible stories could be told, because all but two people escaped with their lives.

As always in these situations, when many are running out, there are those people who take it upon themselves to be running in. This is a story about some of the people who were running in. People from all walks of life and training were sticking around to fight for their community. These men and women ranged from young to old – utilities workers, water truck drivers, equipment operators, countless firefighters, police, and EMS and health care professionals.

This short book is the story of three Fort McMurray firefighters – Jerron Hawley, Graham Hurley, and Steve Sackett – who made notes during the fire and later wrote their story down. Writing about the fire was a way for them to digest their experience and compare stories; it allowed them to accept what had happened. They stayed together for the first six days of the fire, forming a strong bond. The stories in this book are told through their eyes and do not reflect the experience of the Fort McMurray Fire Department as a whole. A community of people helped during the fire. In many cases, the actions of complete strangers working alongside one another on the ground were nothing less than heroic. This event has shown that, in Canada, we are still willing to step up for one another. This book presents a tiny glimpse into the massive effort undertaken during that extraordinary time.

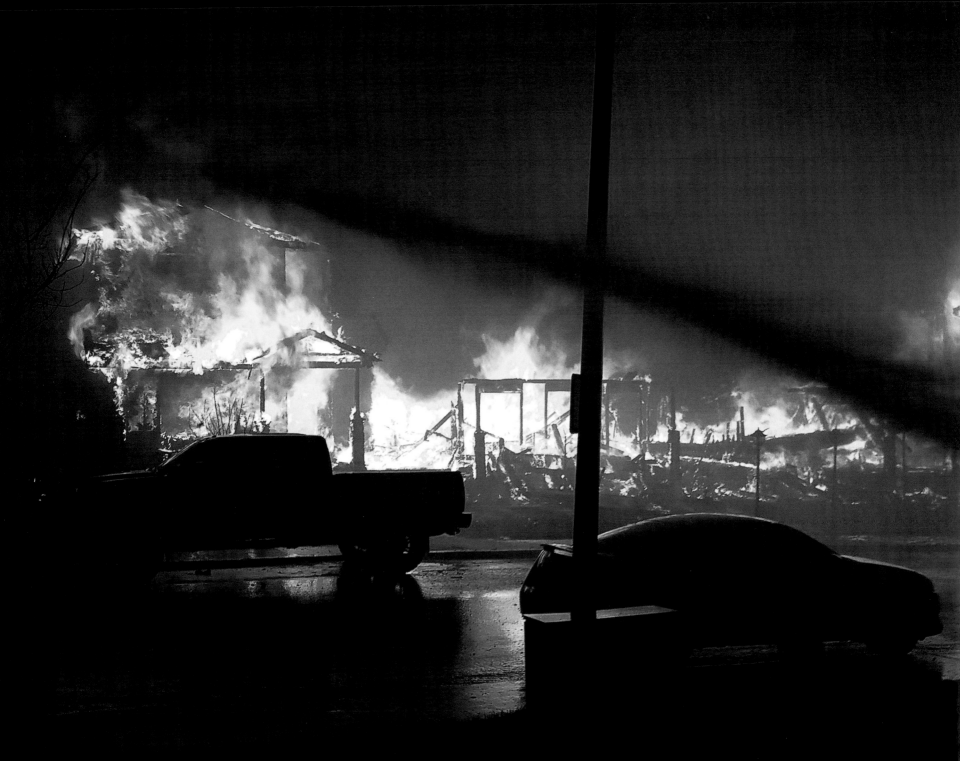

Introduction

Fort McMurray is a city located deep in the boreal forest of the Regional Municipality of Wood Buffalo in northern Alberta. The powerful Athabasca River, fed from the glacial waters of the Rocky Mountains several hundred kilometres away, flows through the heart of town. The Clearwater River enters the town from the east and joins the Athabasca at the north end of downtown Fort McMurray. Two other smaller rivers, the Horse and the Hangingstone, weave into town from the south and empty into the Athabasca within the city limits. These four rivers create the hills and valleys that the city is built upon. Downtown Fort McMurray was built on the floor of the valley where the Athabasca and the Clearwater Rivers unite. Most of the residential areas are located at the tops of the valley but some are lower, on the flood plains. In the spring and summer, the landscape of Fort McMurray is painted green in a sea of mostly spruce, aspen, and poplar trees that create a beautiful backdrop in the hills and valleys. By winter the green has faded into a blanket of white, and the northern lights are often seen dancing in a ghostly parade of deep reds, purples, greens, and blues across the starlit sky.

There is more to Fort McMurray than just natural beauty, however. Oil sands – in which oil is naturally combined with the sandy soil below the muskeg overburden – are found all over northern Canada, but a high-concentration and comparatively easy-to-access formation is found just north of Fort McMurray. This high-grade oil, which is used all over the world, is a source of great wealth for Canada. The employment opportunities this resource offers have attracted people from beyond Alberta's and Canada's borders. The city has a population of over eighty thousand residents, some of whom were born here but many of whom have come from elsewhere.

The average age of the population is young, just thirty-five years, and due to the region's strict labour and environmental laws the majority of people are highly trained in workplace safety and very knowledgeable about what to do in the event of an emergency.

The need for an emergency response team was evident even when the community was still small but growing. In 1974, Roy Hawkins created the Fort McMurray Fire Department (FMFD) and acted as chief, developing the basis of the current fire department. That original small department has grown to 160 full-time members today. All members are trained to the standard of a National Fire Protection Association certified firefighter with a minimum of emergency medical technician (EMT-A) qualifications (which allows you to work on an ambulance, administer certain drugs, and perform certain procedures). The fire department is an integrated service, meaning it includes both the ambulance and fire services. Five fire halls are located in the city: No. 1 is downtown, No. 5 is in the south end, No. 4 is in the north end, and No. 3 is in Thickwood in the centre of Fort McMurray. No. 2 was converted into the dispatch centre. Firefighters work four shifts – A, B, C, and D – made up of two 10-hour days and two 14-hour nights followed by four days off. The 24 hours in the middle of the shift is commonly known around the hall as "short change."

The spring of 2016 was abnormally dry. The snow had melted early and the grass and trees hadn't had a chance to green up yet. Every year this transition from winter to spring causes a higher risk for forest fires. The spring of 2016 was no exception and the fire department had been busy fighting forest fires within city limits. These fires had been contained and extinguished before they had a chance to affect structures in town. While the fire department was busy fighting these relatively smaller fires, there was a fire burning roughly sixteen kilometres south, outside the city limits. This fire was outside of the fire department's service area and was named by the Forestry Service as the Horse River fire. This fire seemed a non-threat at its beginnings but eventually grew into the fire that caused an entire city to be evacuated, and changed Fort McMurray forever.

Damage to Fort McMurray Neighbourhoods

SMALL/NO LOSS

1. Downtown
2. Draper
3. Fort McMurray International Airport
4. Gregoire
5. Prairie Creek
6. Saline Creek
7. Thickwood
8. Timberlea

SOME LOSS

9. Dickinsfield
10. Parsons Creek

SERIOUS LOSS

8a. Timberlea (Mckinlay Cres./Walnut Cres.)
8b. Timberlea (Prospect Dr.)
11. Abasand
12. Beacon Hill
13. Centennial Trailer Park
14. Saprae Creek
15. Waterways
16. Wood Buffalo

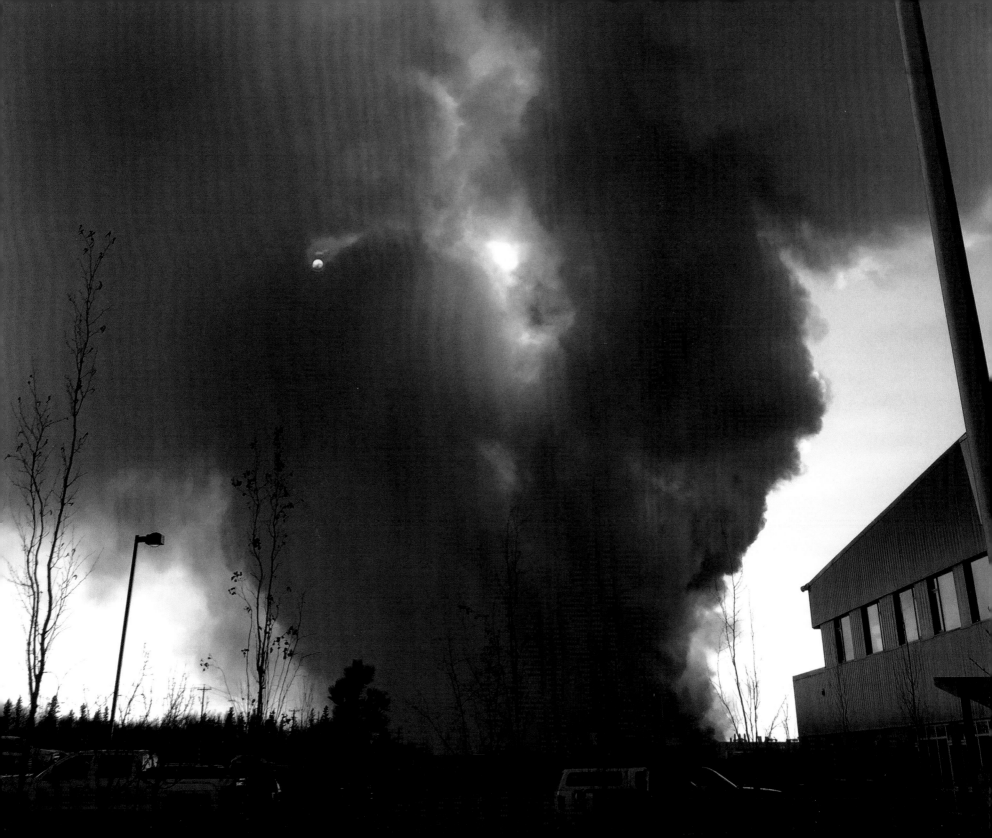

MAY 3
Beacon Hill

I woke to a beautiful spring day in Fort McMurray. Spring is my favourite time of year, especially here. When spring rolls around in northern Alberta, it means that we've survived another nasty, cold winter and the days are getting longer, which tells you summer is around the corner. On this morning, just like every other morning, my dapper golden retriever, Gally, came storming into my room, hiked himself on the side of the bed, licked my cheek, and waited for my eyes to open to start wagging his tail frantically, knowing he was about to get breakfast. Carlene, my beautiful, brown-eyed, dark-haired wife, left for work at 5 a.m., and I was sleeping in because I was switching from day shifts to night shifts. I got out of bed, followed Gally, who made it seem like he hadn't eaten in a year, filled up his food bowl, and poured myself a coffee.

I was feeling a bit tired as the two 10-hour day shifts that weekend had turned into 16-hour shifts due to the forest fire that had broken out on the northeast side of Timberlea, a neighbour-hood north of town. We fought hard and knocked down the fire until it was under control and continued to the second day shift, where we extinguished "hotspots" from early morning to evening. A second fire had started at the same time southeast of Fort McMurray. When fires occur outside of city limits, they are fought by the Alberta wildfire firefighters, a group I can't say enough good things about. On May 3, the city deemed the fire south of town out of control but not an immediate hazard to the city, so the Fort McMurray Fire Department alongside Alberta Wildland Firefighting focused our attention on the fire in the north of town.

After finishing my coffee, I took Gally for a walk. We followed our normal route, but it was the warmest day we'd had all year – by about noon, it was already 30 degrees Celsius – and Gally

was starting to overheat. We decided to head home. I walked out to my back deck and watched as three massive plumes of smoke poured straight into the sky from that fire south of town. Luke MacLennan, a long-time friend, pulled into my driveway – he wanted to see if I'd heard anything new about the fire. I asked him if he wanted to go for a drive and maybe check it out to see if it was close enough to the city to be worried. We drove over towards the Fort McMurray Golf Club in Thickwood – a lot of people were doing the same, and traffic was heavy. As we were approaching Real Martin Drive, we could see flames shooting up the trees – "candling." I heard one of our fire trucks screaming behind us. We raced back to my house so I could get my uniform and report to work. As I left the house, I saw my neighbour, who was holding her six-month-old baby. She said, "Jerron, is this bad? Should we leave? I'm scared." I told her to pack the essentials and listen closely to the radio. I ran back inside, gave my best bud Gally the biggest hug I could, got in my truck, and drove to Hall 4.

When I arrived at Hall 4 (which is located in Timberlea), all the front line units were gone and two guys from my shift, Sam and Kyle, were already there, and another member, Shantz, showed up moments later. We sat in the kitchen and waited, and then the fire tones went off: "Any Members respond to Hall 1 with any available apparatus." I had been on the department for only two years at this point but I knew that there was never a tone page to go through the halls like that one. We headed out to the bays, and jumped up on the three-ton wild land unit while Shantz, Sam, and I board the Ladder. Out the doors we go, having little knowledge of the awakening fire roaring through the south end of our city. Cars were filling up the southbound lane quickly, and we pulled into the Hall 1 parking lot, in downtown Fort McMurray, and joined about 20 members. When you usually see the guys and girls you work with on FMFD, you greet them with a smile or a nice hello. This time was different – you could read on everyone's face that this was "it." Scattered members tried to coordinate crews and plan tactics. There was a one-ton Alberta wildfire pickup truck with a 200-litre water tank in the back filling from our hose in the

bay. The captain of that crew asked for a few guys to join. I stripped off my uniform and threw on our issued wildland coveralls and grabbed an orange hard hat and a pair of work gloves. And it was then that I met up with Steve Sackett. We had met once before, outside of work, when I was hiking with Carlene, and little did I know how much of an impact he would have on my life. Whoever was looking down on me that day put us together for a reason.

"Hold on tight back there, guys," the captain of the one-ton yelled at us as we headed out of the bays. We sped up the southbound lane with the highways blocked by people trying to leave. We had no choice but to take the shoulder and some of the ditch to get to where we needed to go: Beacon Hill. Standing on the back of the truck, I looked at the distraught faces of people in their cars stopped bumper-to-bumper on the highway. People were holding their hands up as if they were praying for us as we headed into that black cloud of uncertainty. I'll never forget it. Although we were responding to an emergency and racing up the hill, it seemed like everything was in slow motion as we passed each and every single person. It was starting to sink in. *This is the one . . .*

We pulled into Beacon Hill and met another fire crew. One of their members said, "There are still people in their homes – we got to get them out of here." Visibility was at a minimum. Flames engulfed trees on both sides of the road. We continued into the heart of the neighbourhood, jumped off the back of the truck and split up on the street. I ran up to the first house and smashed on the door – "Fire Department, anyone inside?" We waited a few valuable seconds and then ran to the next house. I'll never forget reading the first note on a door – "Evacuated safely, may God help us all." Those words threw me for a complete loop. "Hawley, did you find anyone?" Kyle asked, as I stood still like a deer in the headlights. I replied, "Not yet." —*Jerron*

O.C. **/2016**

Province of Alberta
Order in Council

ORDER IN COUNCIL

Approved and ordered:

Lois Mitchell

Lieutenant Governor
or
Administrator

WHEREAS the Lieutenant Governor in Council is satisfied that an emergency exists in the Regional Municipality of Wood Buffalo as a result of wildfires, which have caused extraordinary losses and damages to residents, businesses and others located in the Regional Municipality of Wood Buffalo;

THEREFORE the Lieutenant Governor in Council declares that a state of emergency exists in the Regional Municipality of Wood Buffalo.

CHAIR

Alberta

For Information only

Recommended by: Minister of Municipal Affairs

Authority: Emergency Management Act
(section 18)

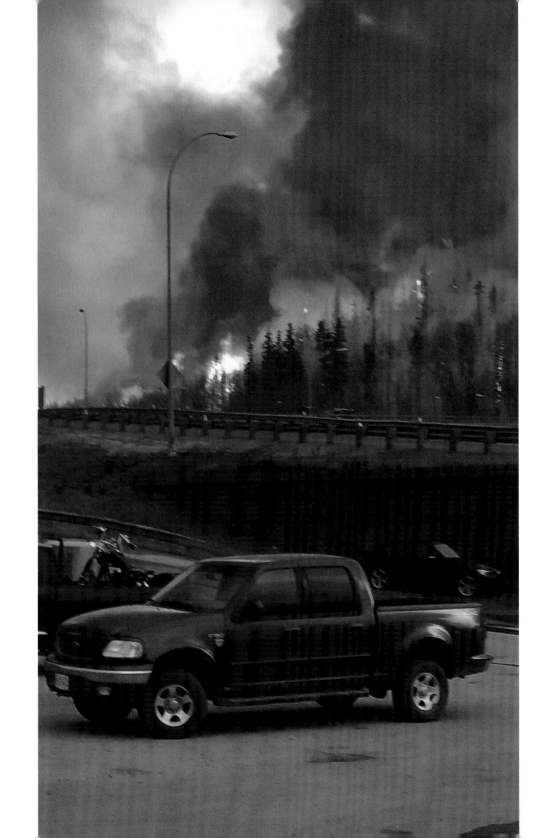

We entered Beacon Hill with our pickup, Hall 5 tanker, a forestry sprinkler truck, and one pumper truck. Seeing the speed that this fire was moving and already destroying homes, we rushed down to the end of the Beacon Hill neighbourhood.

When we arrived, we hopped out and began banging on doors and alerting any evacuees who hadn't left yet. We split up and spread out in order to clear homes faster. We were leapfrogging from house to house, banging on every door and helping anyone who needed assistance. We came across a man scrambling to load his things into his pickup in his driveway. He said his wife was in the house getting the baby ready. We charged into the house and helped her with her baby and her necessary belongings. We helped her to the truck waiting outside. The car seat was in the rear seat but it was covered with their belongings and suitcases. One of our boys put the baby in the front seat basket, put the seat belt on her, and closed the door, and we sent the family away hoping they would be safe.

Smoke and embers were blowing wildly around us, houses were lighting up behind our every move. We had all temporarily lost one another at some point but as we were running to the next homes, we could see one another popping in and out of houses, giving us a general idea of where each was. We met up again at the last street. The fire had gone from one end of the community, picking and choosing what houses it wanted to burn, and had worked its way towards us.

At this point I was getting concerned. This community, like others, has one way in and one way out. I was very aware that our exit was likely completely blocked at this point. I remember telling a member of my crew that our only exit may be down the as-yet unburnt forest of the western slope of Beacon Hill.

Unburnt fuel is not a good place to be near as the fire will likely be there soon but that was our last option if it came down to it. It was getting hot, and we were at the far end of Beacon Hill when Hawley (Jerron) and I decided we needed to find something to cover our faces. We went to a garage located in the backyard of someone's home. When we went in, there were only small spot fires from freshly landed embers on the grass. We kicked in the door and it closed behind us. We were in there maybe a minute looking for something, anything to cover our faces. I found a mask fit for use in a paint booth and as I was picking it up, the garage door flew open. Hitchcock had kicked it open and was yelling for us to get out. We barrelled out of the garage and out of the yard, which was now on fire. About thirty seconds after we left, we looked back at where we had been. The yard, house, and garage were now fully involved with flames.

In spite of the deafening sound of the fire and propane tanks from every house exploding, I could hear the sounds of sirens coming from downtown, from below Beacon Hill. I could hear constant airhorn blasts and I knew those blasts were our mayday blasts. (Three airhorn blasts mean mayday.) Not knowing what kind of hell they were in, I feared the worst for my brothers down the hill. **Steve**

We made our way to the untouched northeast corner of the neighbourhood and were having a quick meeting with another crew when two young ladies came running down the street towards us. I have no clue how they managed to still be in there. They were yelling to us that their dogs were locked in their house back up towards the fire. I stopped one girl as she was trying to run by me. She pushed past me and was set to get her beloved pets. I learned a valuable lesson then, and this is where I first saw how big the hearts of my brothers are. Without thinking, they got the address and we took off, back up the street to get the dogs. One of the boys kicked in the door and one dog was right at the entrance. Tovey and I took care of that one, while the other boys were farther inside the house looking for the second. I was laughing because Hawley was trying to catch the cat. I would see the cat bolt across the house and then a firefighter running after it, hot on its heels. Then a few seconds later I would see the same image going the other way. After a few minutes, we had the dogs. We left the door open and ran for it back to the trucks. The boys took their hard hats off and filled them with water for the dogs. The dogs just sat in the front of the truck box, the fear clearly evident on their faces. *Steve*

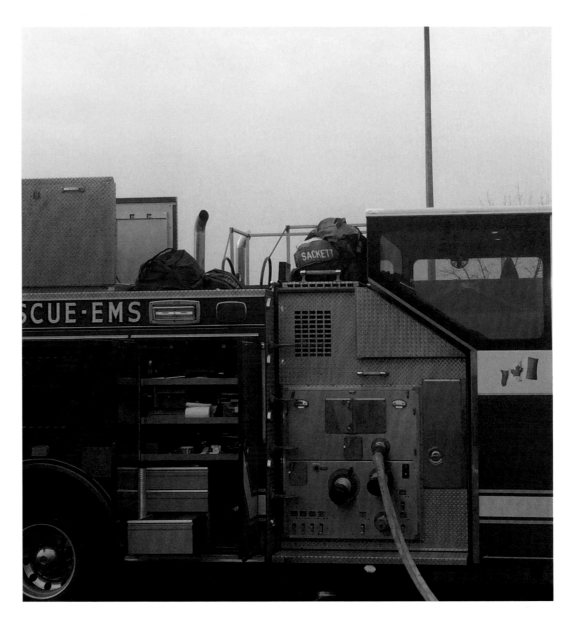

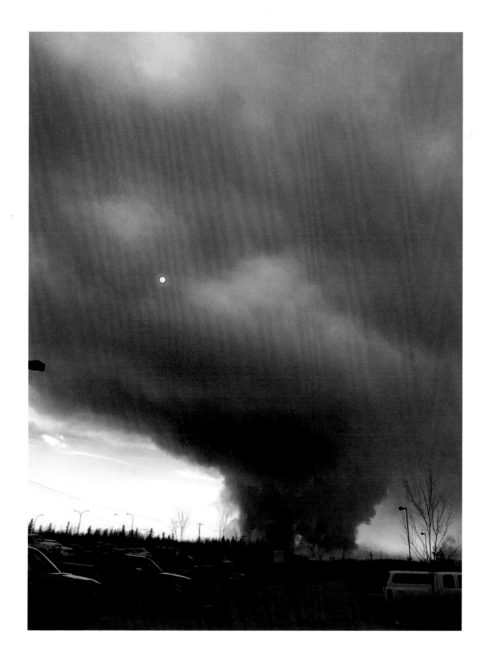

Our crew and the other crews decided to meet up near the hockey arena with the Slave Lake chief who was already up there. We had no hydrant water and the tanker was empty; everyone was believed to be evacuated. The chief was describing our situation — we were told the Shell fuel station at the entrance was on fire and we were going to have to make a run through the fire in the trucks. As he was briefing us, a massive explosion went off. It was so big we could feel it in our bodies and it followed with a fire ball hurling into the sky south of us. Without flinching, the chief continued talking to us, saying "I hope no one died," and then carried on talking as if nothing had happened. Dave Tovey, Adam Chrapko, Jonathan Bruggeling, Hawley and I hopped in the box of an FMFD truck hauling a sprinkler trailer. We blew through our exit unharmed and made our way down Highway 63 to our next stop, the neighbourhood of Abasand. *Steve*

I had been in Edmonton visiting my best friend, Damien Maas, a passionate and talented paramedic and firefighter, when I got a phone call from Sarah, the love of my life and mother of our child. She said that her horses were being evacuated from their stables due to heavy smoke from a nearby forest fire. Damien and I drove back up to Fort McMurray that night. The next morning the smoke in the sky was in its own way spectacular and, in the truest sense of the word, awesome. I had never seen anything quite like it. But when I went downtown to run an errand later that morning, that was not the smoke I saw. I looked to the east, and what I saw on the top of the valley stopped me. I didn't get out of my truck. The smoke had the appearance of being under pressure, shooting straight up as if coming from a steam engine. The smoke I saw when I was on the way downtown had been almost cloud-like and stationary. This was different. This was dynamic, which meant it was close or large, or both. And in true millennial fashion, I took pictures and video and sent them to Sarah. Far more unnerving than the almost biblical scenery ahead of me was that every single person in the parking lot was doing the same thing, frozen on the spot. "I've seen this movie," I thought. "Time to go." When I arrived home to get my uniform, I said to Sarah, "You have fifteen minutes to leave." *Graham*

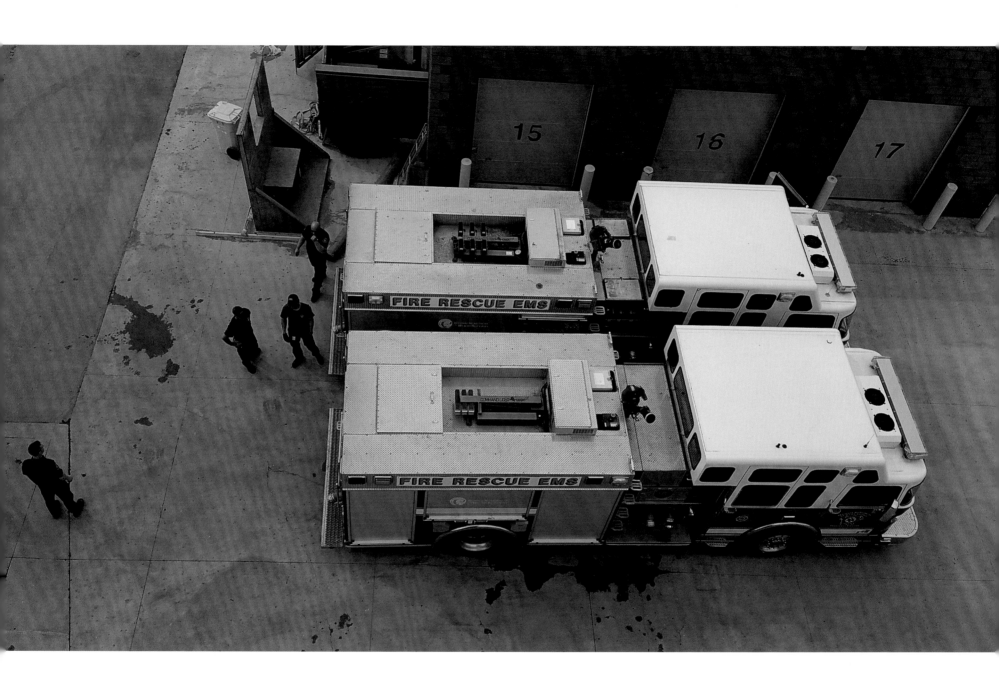

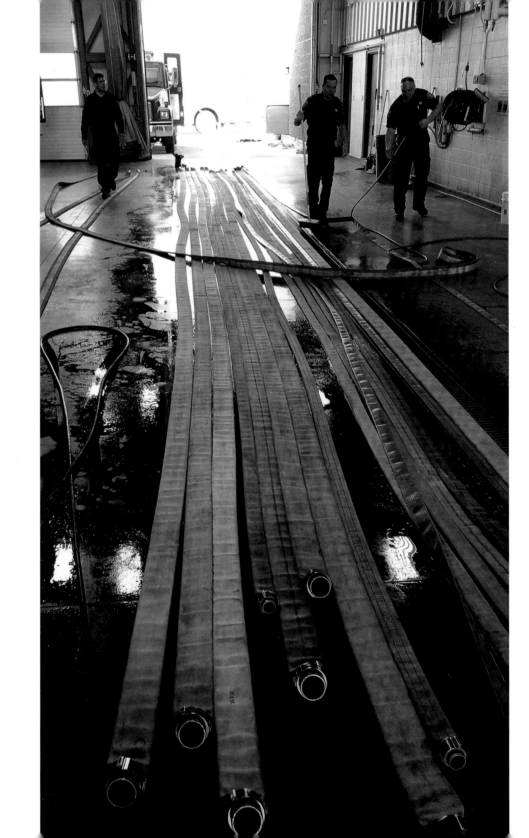

We pulled into the Hall 1 parking lot, which was full of trucks with spaghetti piles of dirty hoses spilling out on the pavement. People were moving with a purpose, some in coveralls, some in bunker gear, the battalion chiefs glued to their radios. At that moment, I received one of the best text messages ever. It was Sarah. She and the farm we had packed up were now out of the city. I was so happy. I have a strange habit of making sarcastic, yet dramatic comments in extreme moments. With a grin and a laugh I looked over at my legendary battalion chief Kelly Kelly and told him, "Everything I love is out of the city, I'm now ready to die on this pavement." With a similar look on his face, he shot back, "Good."

Later, the crew I had started with were broken up. At this point, I looked around and saw an FD dually — a truck with four wheels at the back end — with a bunch of guys just in yellow coveralls, wild-eyed and with rags over their faces. They were going up to Abasand. And I wanted on. Hawley, who is built large and made of bricks, looked at me and said, "Hurley, good to have you aboard," and shook my hand. *Graham*

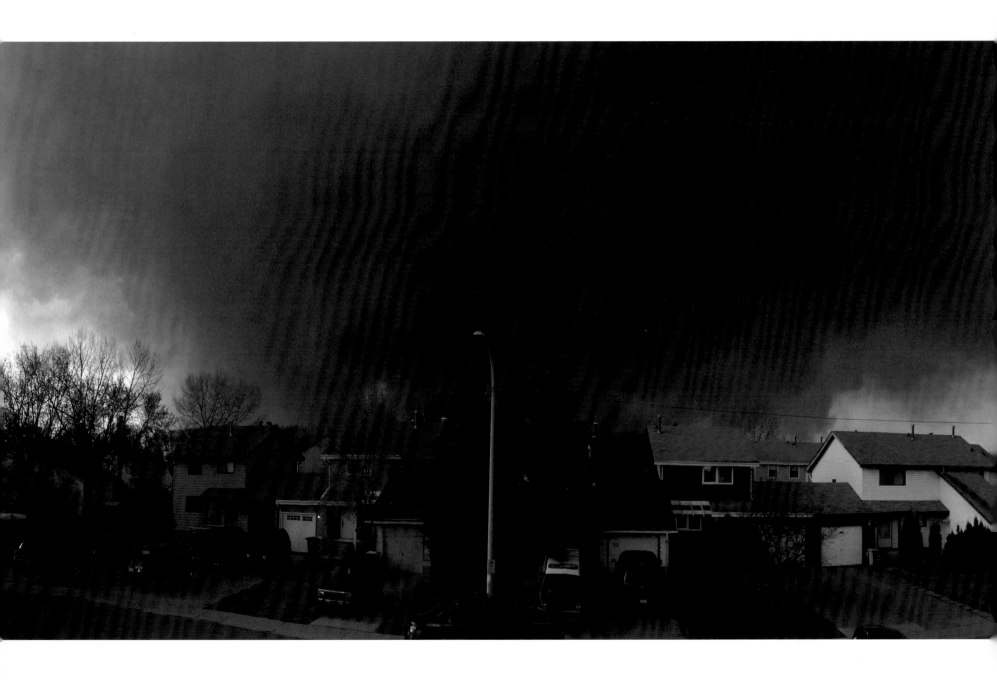

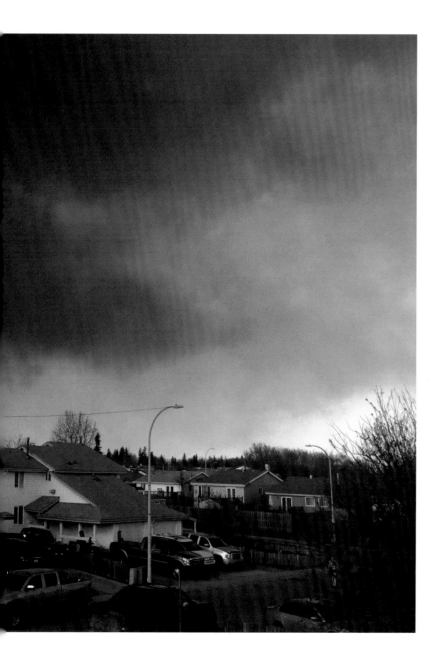

Driving up the hill to Abasand was eerie. We were going in, and three solid lines of traffic were inching their way out. I made eye contact with a few wide-eyed evacuees and wondered what must be going through their minds. We took a left at the four-way stop at the top of Abasand Hill. We drove down to the end and saw that houses were already lighting up. The fire had jumped across the valley between Beacon Hill and Abasand.

Chrapko skilfully threaded the truck and trailer through the abandoned cars, motorbikes, and thick smoke. We decided to park on Aspen Hill Drive and make a stand there two rows ahead of the fire. Our sprinkler trailer is a sixteen-foot enclosed trailer full of forestry sprinklers that deliver fifty gallons a minute, forestry hose, a ladder, and a ton of couplings and connections. We worked hard in the thick smoke and blowing embers and strung out approximately six hundred feet of forestry line; at each connection we plumbed sprinklers inline. We had smaller three-quarter-inch line spliced off to allow more sprinklers to soak the houses. Tovey was climbing roofs and attaching sprinklers to the peaks and shed tops. Any residential garden hoses with sprinklers attached were promptly raised to the roofs to help wet the homes. Any potential fuel near the house, like propane tanks or bags of leaves, were thrown out into the middle of the streets. At one point we were behind a house where the back deck was just starting to light up. We were trying to use a garden hose to put it out but it wouldn't quite reach. We started using buckets and were running a short bucket brigade to put the deck out.

We'd be working as hard as possible, then someone would come running from the front of the house and say forget about it, the front of the house is now on fire. By the time we had our line set up with all the attachments and flowing water, the street would be on fire. There was a hell of a south wind blowing embers onto the next row. Our efforts seemed worthless. We would quickly disconnect all connections and drag all our lines out of the street and move down another three streets to restart. This sequence was repeated a couple of times until we met up with pump truck crews fighting fires further north and west of us.

My home was three houses down. I knew it would be gone. *Steve*

Everyone was busy: some guys were deep in the trees, choking on smoke and stomping out grass and bush fires. Chrapko and I began setting up sprinklers on the rooftops. These houses are all two-storey and we only had a twelve-foot ladder. We would climb up to the first ledge, then pull the ladder up and climb to the roof. We set up our sprinkler and went back to fighting grass fires. *Steve*

This was my first experience with how large fires move uphill. Fire tends to burn faster uphill. When a fire gets big enough, it can start creating its own wind patterns, which can feed the fire. It can turn away; it can push towards you. Here in Abasand, tankers were filling porta tanks (big canvas tanks with a floating rim) along streets facing the green belt. Against a background of heavy smoke, fences, lawns, decks, houses, and tall trees were on fire. Pumper trucks were in and out of the area, fighting fire. We were the sprinkler truck. Our capabilities were only defensive. To ensure the sprinkler has enough pressure to produce a full and proper pattern, long hose lines run from the sprinkler, stretching hundreds of feet to a hydrant, where a pump boosts the pressure. Under ideal circumstances, sprinklers can establish a formidable wet line and stop even large fires, provided they have been placed well enough in advance. These were not ideal circumstances, however. As the fire started moving uphill, you could see large swaths of rolling pressurized smoke start to huff its way through the unburnt trees on the plateau ahead of us. A fire spreads in innocuous ways. An ember here and an ember there gently float past. They land delicately on lawns or eaves and begin to fester and become mature fires of their own, while the main fire catches up and fills the gaps.

It became apparent that fighting small fires was just as important as containing big ones. With no tools in hand, I began scanning people's lawns. What had they left out? The next thing I recall is beating a grass fire down with some kid's toy shovel, so the small flames didn't spread towards an intact house. The tiny shovel melted and broke. Tool-less again. A mop to my left. A damn mop. I picked it up anyway and was able to finish what I'd started. You make do. *Graham*

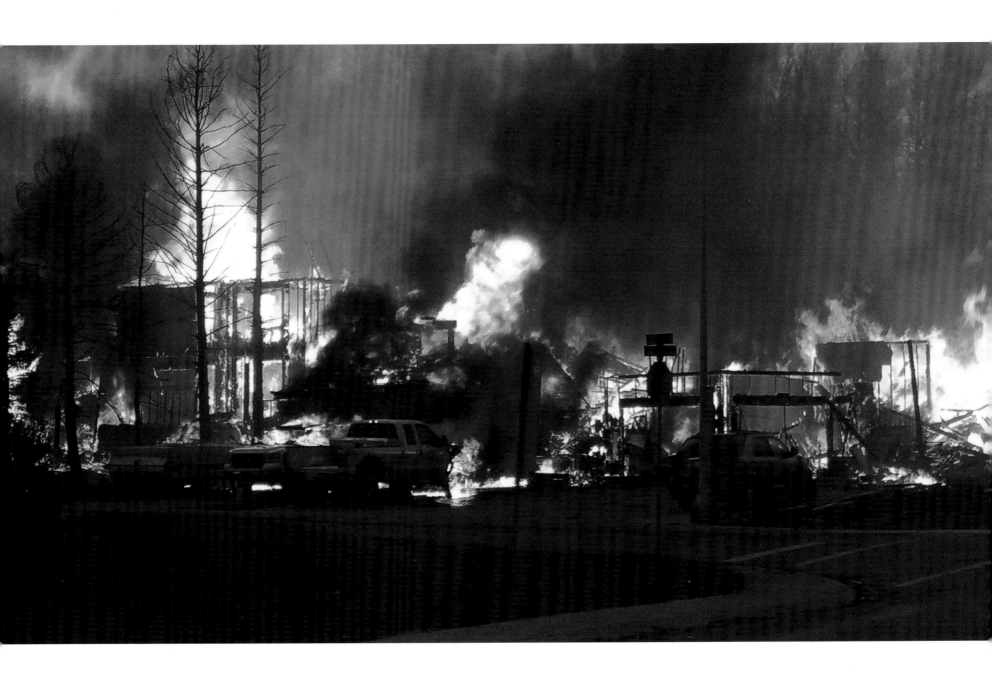

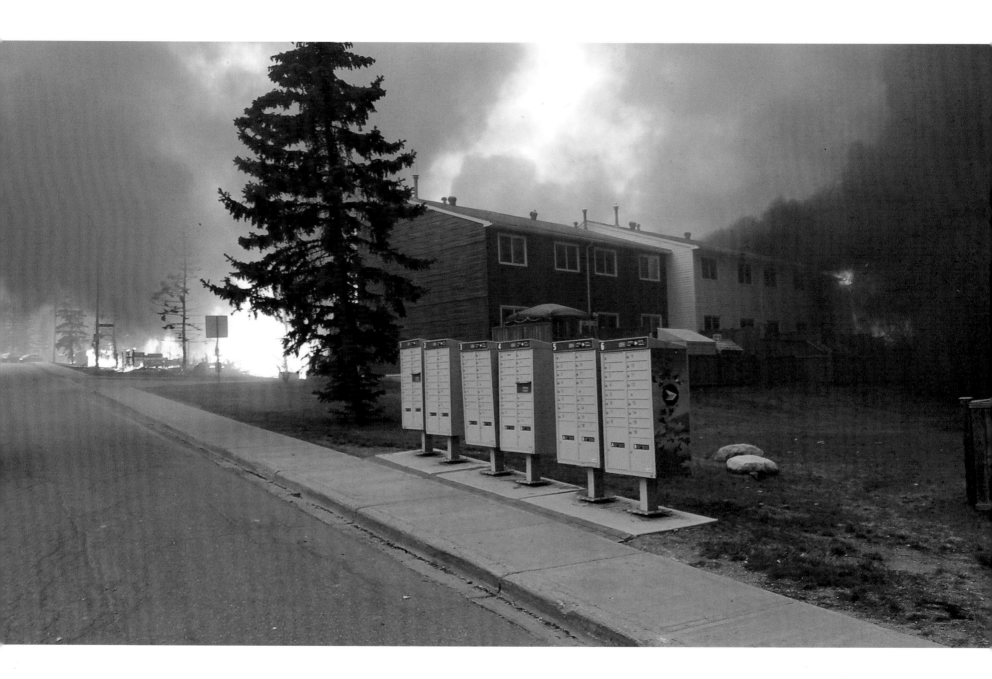

Tall spruce were starting to candle and the heat was coming. "Chainsaws," I thought. "I need a chainsaw." One of the wonderful things about Fort McMurray is that everyone seems to be handy or owns tools of some sort. I booted a garage door down and, by what seemed like destiny, found a fuelled chainsaw on top of a beer fridge. This would make checking for spot fires easier — it meant we could cut down large trees to prevent fire growth and make access and egress points through and between fencelines.

I ran back into the alley and met up with Steve. We hopped a fence that was partially charred and smouldering. We made our way into another garage, looking for tools, axes, shovels, fire extinguishers — anything. And by the time we were out, the siding and soffits were burning. I realized how hot my face and neck had gotten. The rest of the time I spent in Abasand was a blur but more of the same. Jump a fence, fight a grass fire, run a forestry line. The southern tip of Abasand was pretty much engulfed or levelled already and parts of the north were now burning.

We got orders to head back to Hall 1. The ride was quiet this time. We were filthy and just taking in our surroundings. There was flame on the hills on the way back down. It's hard to know what was worse — seeing hills and neighbourhoods actively burning or seeing them black, bare, and smouldering. There was no going back. This community had been changed forever. *Graham*

After being sent to protect and extinguish a fire in a green space behind a gas station at the entrance to Wood Buffalo, a newer area of town, we were sent to Timberlea. Going up Walnut Crescent was interesting. As we drove through the city, we encountered only emergency vehicles. It was so smoky, you couldn't see much more than 20 feet around you. When we arrived we were tasked with assisting pumper crews and attaching our sprinkler lines on fences, lawns, even roofs. I remember getting on the roof of a garage with no ladder. As I found a way to attach and aim a sprinkler, I could see a line of eight to twelve small lots, five or six apparatuses, twenty to thirty people like me, doing anything they could: driving large vehicles, ripping fences down, climbing roofs, hauling hose lines, getting wet, getting hot, getting muddy,

operating saws, swinging tools, and, remarkably, not getting hurt. I felt as though Walnut was the first time we were able to stop it. It was also the first time I really noticed that there were just as many trucks from other places as there were from the FMFD. It put a lump in my throat. I finished jumping fences and kicking gates open, with no tools, soaking wet, boiling hot, like everyone else.

If there is one thing I can't stress enough, it is that it is an amazing thing to watch a community, a province, a country even, come together. A bunch of first responders had got the word and had stepped up. They felt for Fort McMurray, a town with so much bad press. But here they were. Should any of them read this, I want them to know that should the occasion arise, I will be there. *Graham*

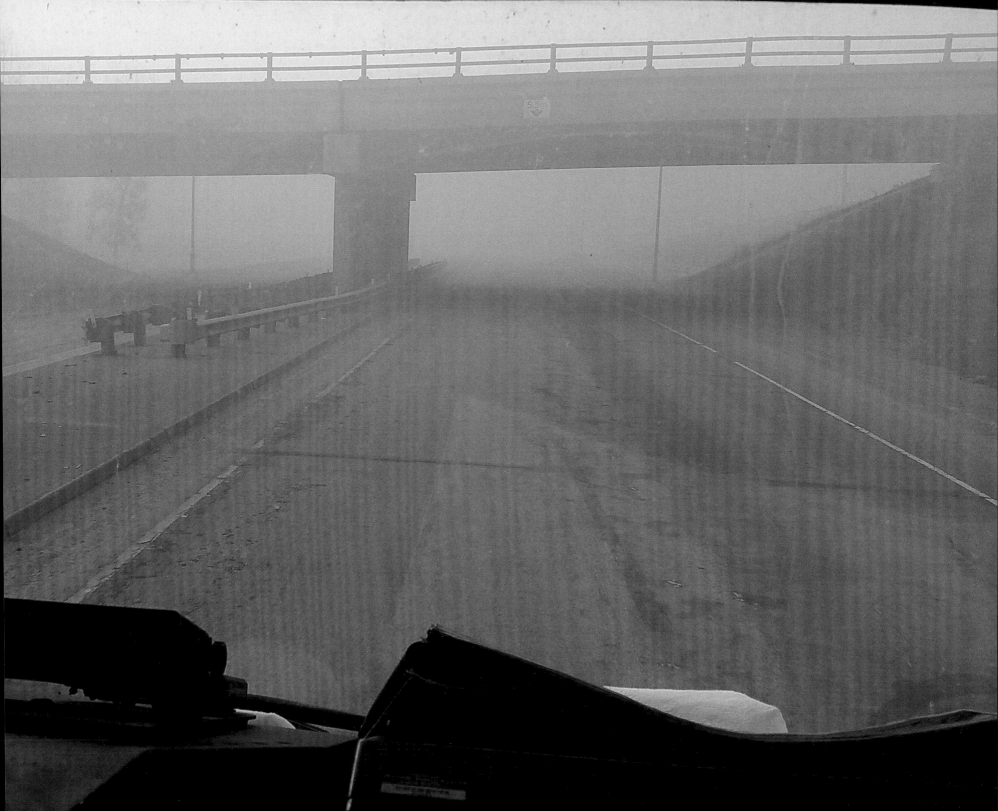

We moved across town while the sun was going down. As we crossed the bridge over the Athabasca, we could see the fire had jumped the river. We drove up Beacon Hill and made our way to Real Martin Drive. Not far down Real Martin, we could see those crews were in the same type of situation we were in. They had major equipment there at that time. We watched in awe — we could do nothing with our sprinkler truck against that fire. We watched as the ARFF (aircraft rescue and firefighting) truck and FMFD trucks, as well as others, held the line ahead of the blaze. It looked crazy and we all thought they were in over their heads. They held their line, though, and did an incredible job of stopping that fire from destroying all of Thickwood. This photo was taken after the fact. We were fighting in the now empty triangular space. *Steve*

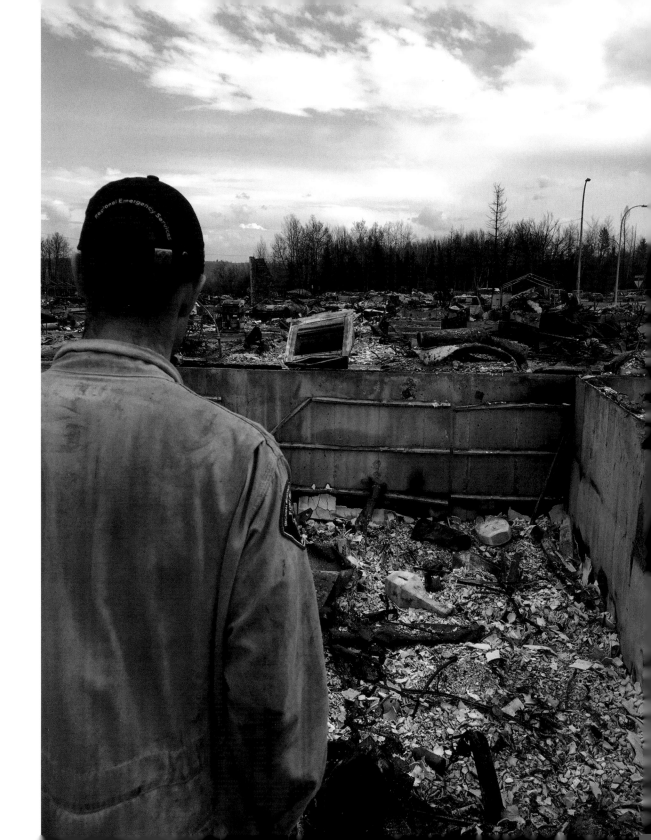

While the battle was being fought on Real Martin Drive, the RCMP told us there was a grass fire in a green space that runs from Real Martin Drive into the Thickwood area. We quickly set up and ran a 65-mm hose straight off a hydrant and down in behind Mac's plaza into the green space. We put a real hurt on it and stopped it. We had some downtime after that so we sat in the pickup and had a bite to eat.

Our Brother Bo Cooper had been in a huge battle of his own with cancer for the past five years. That year a group of people made cabbage rolls, hundreds of them. They put them in small tinfoil containers and sold them for ten bucks each and the money went to the Bo Cooper fund. The extras went into the fire halls for us to eat. While we were in the back of the truck, someone from Hall 3 brought us a tray. We dug into that tray with our bare dirty hands — those rolls were absolutely delicious!

At the time I was renting a room off of Bo. This photograph is of Bo's house after the fire went through Abasand. **Steve**

We soon heard reports of fire on Mckinlay Crescent threatening Walnut Crescent. We arrived on Walnut and the fire from the trailer park was roaring and already threatening the houses. I began stretching a sprinkler line to cool the houses on the north side of the street. The other boys were off hooking into the hydrants and hooking up sprinkler lines further up. It wasn't long before other crews started showing up and we now had a couple pumps on scene. Monitors and hand lines were set up and began protecting the exposures on the south side of the street. The fire was roaring and the wind was blowing embers over the street, the smoke was thick. I was proud to have finished my sprinkler line from the hydrant down the street and all the way around the corner. We were getting really fast at that. *Steve*

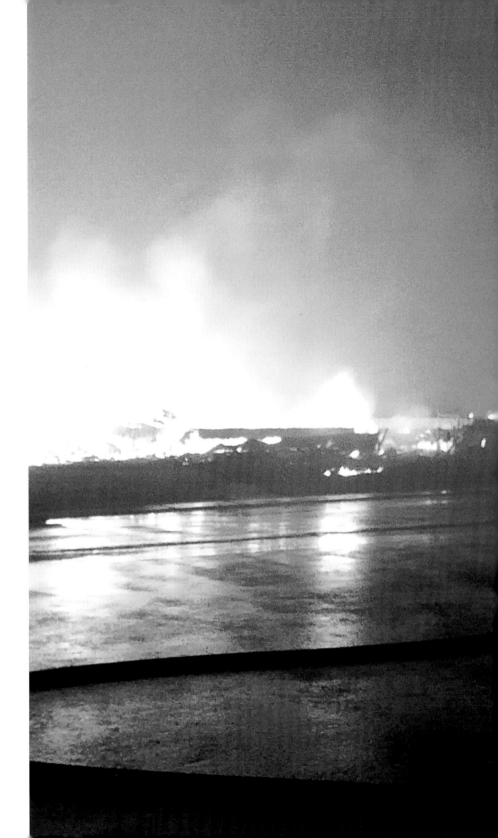

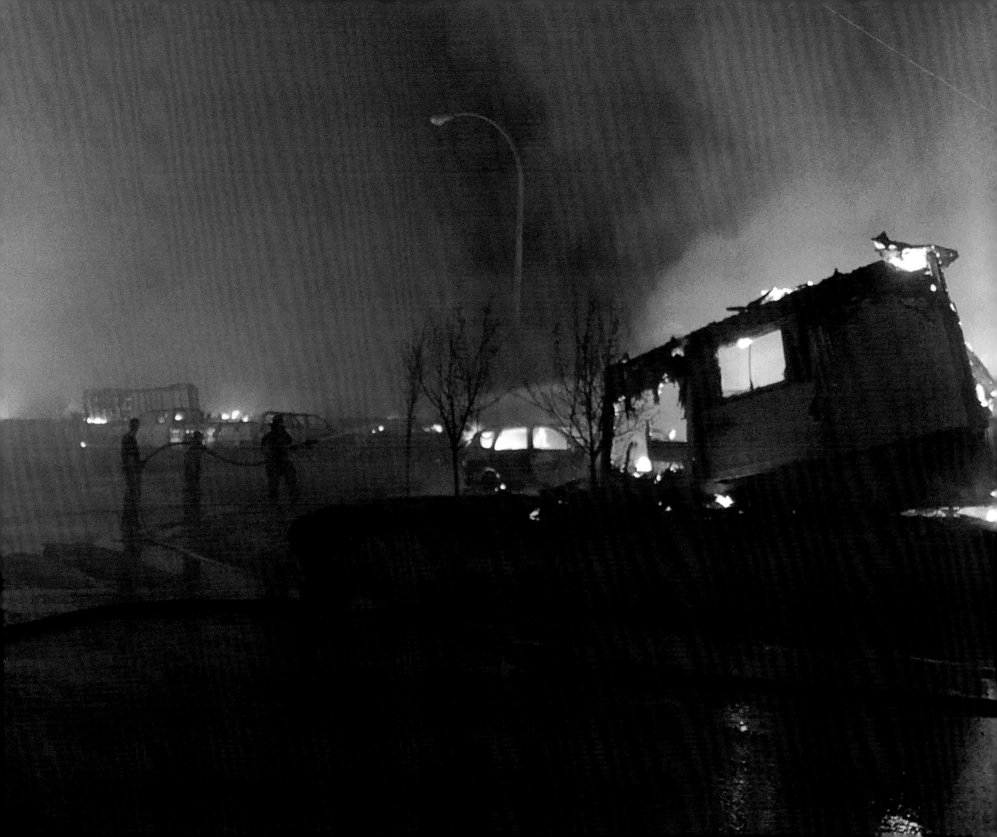

At some point we made our way down to MacDonald Island Park, a leisure centre in downtown Fort McMurray. The first thing I remember doing was stripping down to my uniform pants and issued T-shirt. I ran to the washroom inside the recreation centre. A firefighter I didn't know was walking towards me on my left. He must have read my T-shirt and noticed I was with the FMFD. He stopped and looked at me as I hobbled towards the bathroom door. He started to get emotional. I didn't really think anything of it. I went to the sink and rinsed my face off. I looked at myself in the mirror. I tried to look as natural as possible, pulled out my phone, and took a picture. Emotionally, I was somewhere between laughing and crying. Another part of me was overwhelmed with a sense of purpose. I was alive and above the dirt. *Graham*

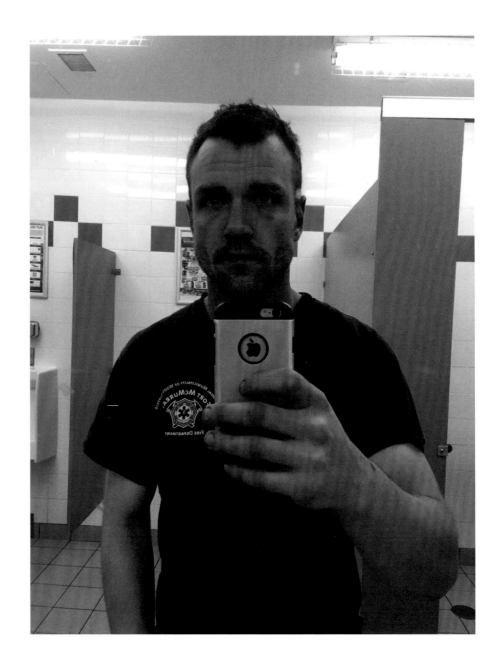

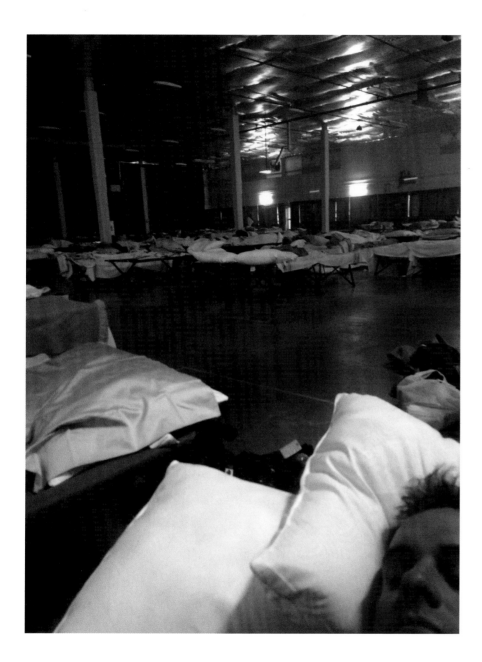

After a quick stop, we made our way down to the MacDonald Island staging area. Hundreds of cots were set up in the curling rink, and each of us found a cot. Some of our members were asleep under thin sheets in their filthy yellow coveralls. We quietly found a group of vacant cots for our crew. I unzipped and peeled the coveralls off my body and let out a sigh, then slowly rolled back my socks. This was the first time I noticed the condition of my feet. I knew I'd felt pain during the day but didn't have a choice to stop and evaluate them. I reached into the top pocket of my coveralls and realized I had taken my cellphone charger with me when I first left my house. It was like finding the golden ticket from Charlie and the Chocolate Factory. My cot was beside a wall outlet so I could charge my phone enough to call Carlene. In the short conversation we had she told me my best friend, Brad Macdonald, had taken her under his wing to get her to safety, as he was the only one besides us to know she was in the early stages of pregnancy. I'll never be able to thank him enough. I then closed my eyes for the first time and fell asleep. It was 5:00 a.m. *Jerron*

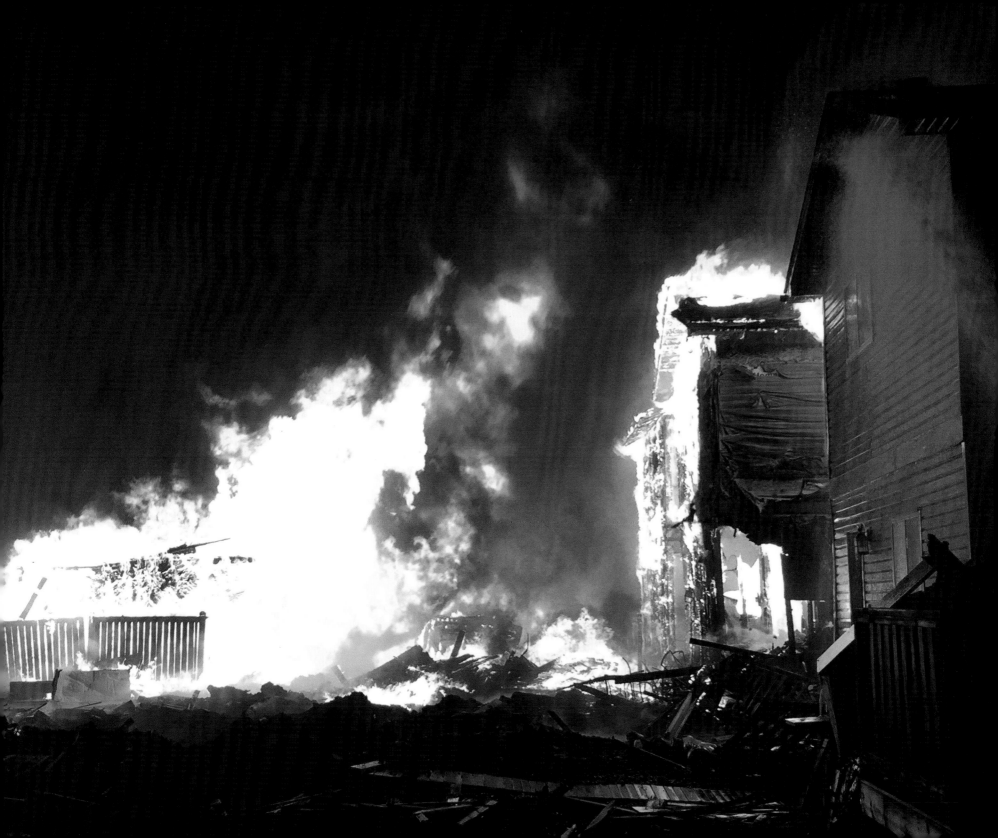

MAY 4
Prospect

woke up after a few hours, saw who was still sleeping, and made my way out to the front of the curling centre. Ate granola bars for breakfast, drank a few glasses of water, and found the rest of my crew. We hopped back in the sprinkler truck and drove up to the southeast side of Thickwood, a neighbourhood on the northern bank of the Athabasca River, to the ball diamonds. We met up with a contractor who was in town with two more fully supplied sprinkler trailers. He gave us a demo on how his equipment worked. The mission this morning was to string a sprinkler line all the way down the tree line of Thickwood (roughly three kilometres).

The morning was calm but in the back of my mind I felt a bit nervous about what might be coming later in the day. We had reports of high winds, hot temperatures, and crossover expected around 1 p.m. (Crossover is when the temperature of the fire becomes higher than the humidity. At this point fire grows at the fastest rate.) That at least gave us time to set up sprinklers, cool the area, and raise the humidity along the tree line.

Hawley and I and a third colleague split off into a cul-de-sac and started pulling all flammables away from homes. We crawled up any roofs we could and started setting residential sprinkler systems on top. We commandeered ladders from people's homes. We made sure to get sprinklers on roofs with cedar shingles. Some roofs were steep and slippery, and we were very careful not to slide off.

Trucks from other communities were in town now and they were starting to set up along Signal Road. We knew the fire was coming in from the west and we had to stop it at this tree line or we would lose Thickwood. —*Steve*

Sackett and I split up from the crews with a pickup truck as we loaded up portable pumps that were fed water by hydrants and that supplied needed pressure to the sprinkler lines. We located a hydrant around the corner and started setting up the pumps, while the other members of the crews were rolling out hundreds of metres of hose and attaching the sprinklers. We were attempting to cover about a two-kilometre line between the houses and tree lines and saturate it with water for a barrier. If the fire crossed this line, Thickwood would be lost. *Jerron*

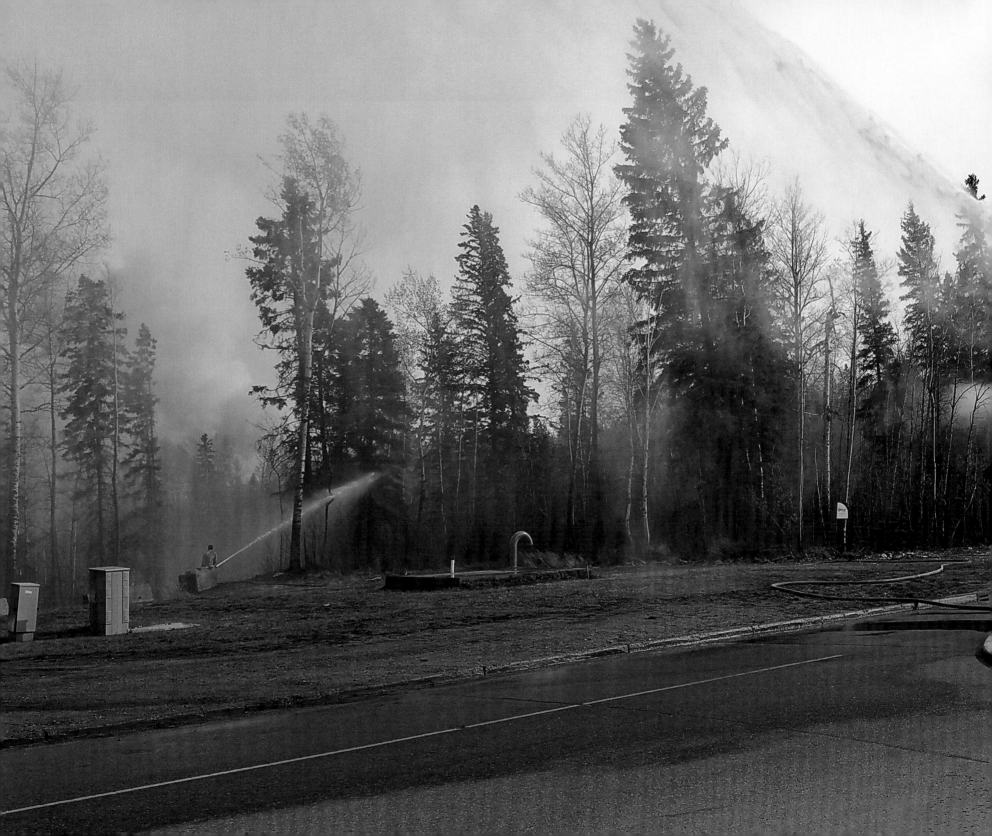

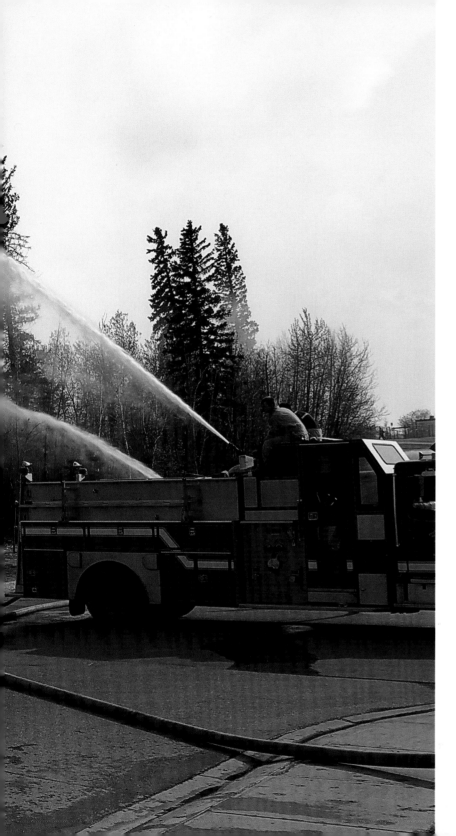

We continued down the line, looking for spot fires as morning grew into afternoon. Scattered crews, along with new volunteers, were now working together. Aerial trucks, pumpers, ARFF, rescues, all set up along the south side with our sprinklers spraying water on the trees. We would help a crew lay down a few lines, set up, knock down or cool off hotspots, then move down the line to the next truck.

We decided to head down to the baseball diamond as we noticed the winds growing to 60 or 70 kilometres an hour and met a few crews gathering for another assignment. Now our focus was on the water treatment plant located on the southeast side of Thickwood. Fire had made its way around the corner and was heading straight for our main source of water to the city. We had crews take multiple routes down paths and roads to prepare for the arrival of the fire. If we lost the water treatment plant, the whole city would be a loss: no water, no fight. The crews essentially stood their ground. They battled hard, and even with fire literally rimming the entire exterior of the building they were able to save the whole complex. *Jerron*

Our crew had stayed in Thickwood because of a potential flare-up on the southeast side, but we were stranded there for what seemed like hours. It is an uneasy memory for me. While we were waiting for an assignment, we watched as winds shifted north to south in almost the blink of an eye and in the distance fire was entering the north end of Timberlea. When you know other members are fighting with everything they have and you're sitting down seeing the rage of smoke in the sky, you get a sickening feeling.

An hour or two passed — they seemed like days — when we finally got word we were being rerouted back to Mac Island. We piled into the trucks, and for the first time I was separated from both Graham and Steve. I was on the back of the truck with a few of our guys and we came to the realization that we could very well lose our homes in Timberlea. As soon as we were dropped off in the parking lot, we jumped into the car of one of our members and made our way to Timberlea to see exactly where the fire was and what it was doing. The guys dropped me off at my house.

My mother's car was in my driveway and I decided to just load as many of my belongings as possible into it. (My mother was safe back home in Cape Breton.) I called Carlene. "Car, I can't talk long, the fire is getting real close to our house and I need you to as quickly as possible tell me anything you want me to get right now." That's a phone call not many people receive, let alone want to get in their lifetime. Carlene listed off items that meant the most to me, and then said, "I only want you to come here." I told her I was safe and that I loved her and then drove to my brother Loren's house to rescue what I could. *Jerron*

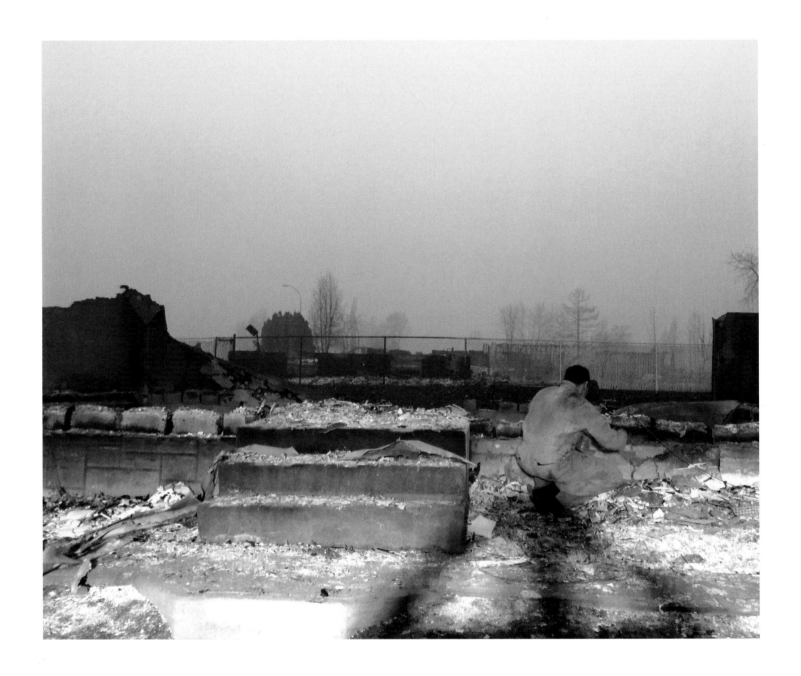

That evening, after the fires in Thickwood, I saw Steve Sackett driving a rescue truck. We drove up Beacon Hill. The hillsides were still smouldering, everything was black, and there were still vehicles in the ditch. We pulled in, and I could see over to Gregoire, the area of Fort McMurray on the other side of the intersecting highway. It was levelled. I couldn't take my eyes off my surroundings. We pulled into my old street. Every house had been burned to the ground. We stopped in front of my house: a pile of rubble where my childhood used to be. I was fighting my emotions to the point of feeling numb. It wasn't until later that I was able to articulate my feelings. It was on my first set of days off that I started writing about it.

This picture is me at my parents' place, collecting a bottle of ashes from my childhood home. My father had asked me to grab one thing: a picture of his father, who was a World War II vet, in uniform. By the time I was able to get there, Beacon Hill was entirely engulfed. A sense of failure came over me. *Graham*

After leaving my brother Loren's house,
I had made my way back down to Mac
Island. I looked at my phone to find a
message from a firefighter in my original
shift. They were battling at the airport but
had now been instructed to join the fight
in Timberlea. He told me to head for the
highway, and he would stop to pick me up.
In the distance, a rescue truck approached
— it was Graham and Steve. I informed
them about Timberlea and we raced back
up the hill to start working. *Jerron*

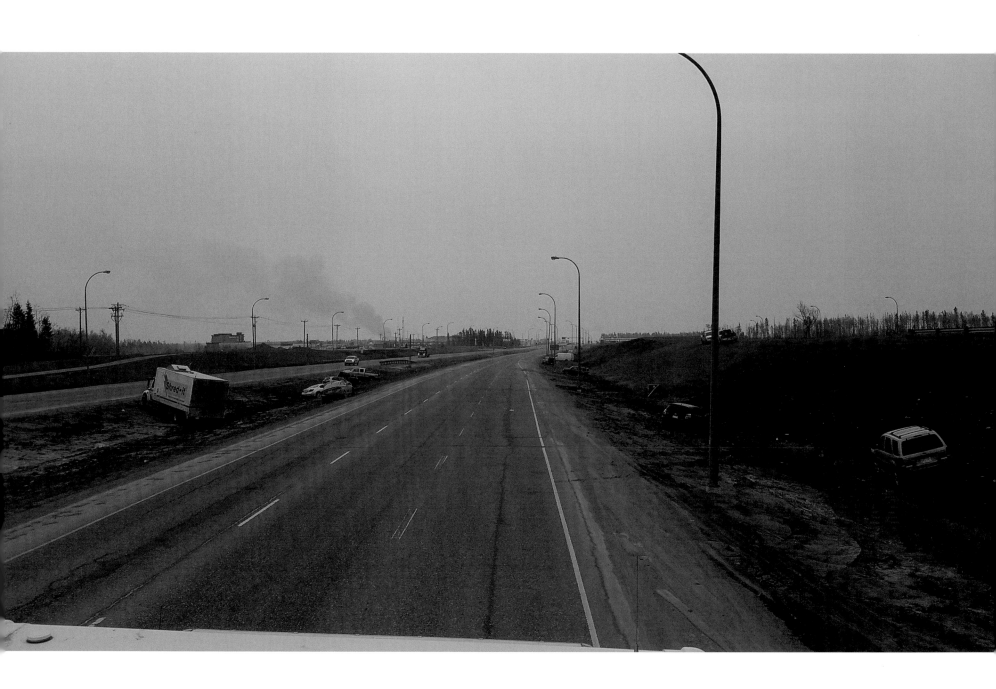

Prospect was one of the newest areas in Fort McMurray. The houses were close together and built in a new-style construction — very pretty, but very flammable. There seemed to be two fronts for us to fight. Rather than be on the residential side and have the fire come towards us from the trees, the fire had also ignited houses. For simplicity's sake, these directions are approximate: the fire was moving south. On its west side, houses were on fire, and on the east side, the forest — our line in the sand — ran east to west. From this point I can remember only major events and their vague order. We were tasked with establishing a wet line to hold the fire on the forested eastern side. We had a large cutline that ran five hundred metres steeply down to Highway 63 below us. We assisted a Lac La Biche pumper that was in place. It ran hose lines and had its deck gun pointed towards the trees. Firefighters in dirty coveralls ran up and down the hill, dousing hotspots or moving equipment. Fire was visible but the wind was still in our favour and it was now nighttime. The fire on the east side looked to be more intense and even dangerous. A lot of the work required heavy machinery. Dozers were now showing up. And there were pumpers tied into hydrants throwing water from their deluge guns.

Graham

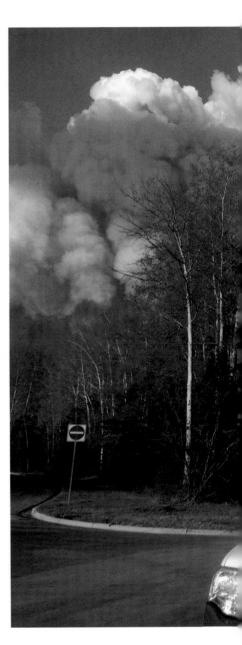

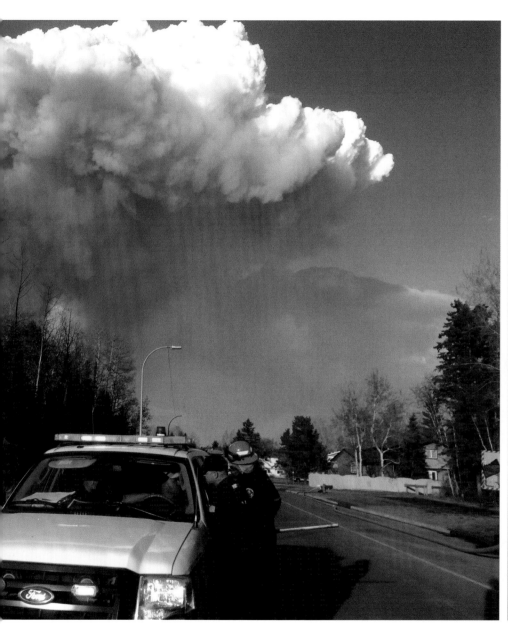
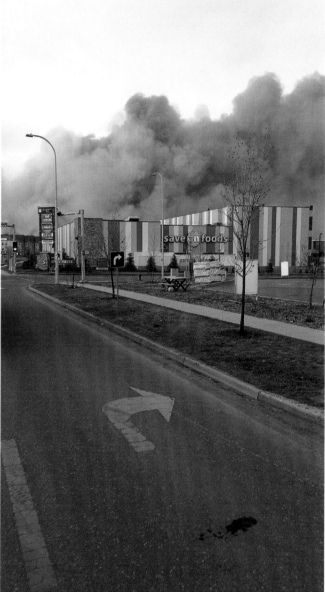

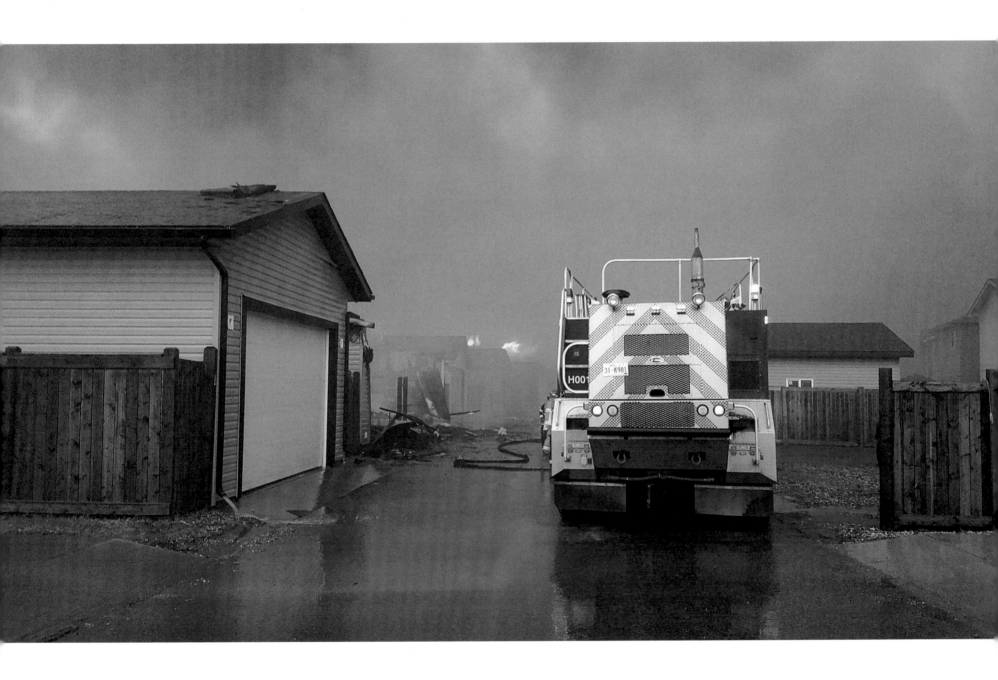

Hawley and I were at the rescue truck grabbing some shovels when one of our FMFD brothers came around the corner. He told us his home was just a quarter mile down Diamondstone Ridge, just north of the main fire. He said he had packed some important belongings and pictures of his family, and that they were just in his front entrance. Hawley and I didn't bat an eye — we said we would go get them. Our colleague was a bit taken aback and he said, "No, I couldn't ask you to do that." We jogged through the trees until we popped out onto Diamond Stone Drive and kept on towards his home. Ahead of us we could see the firestorm blowing overtop the houses on Diamondstone. Small grass fires were lighting up on lawns. We stomped out what we could and decided we didn't have time to put them all out if we were going to make it back through. We ran a ways further until we stopped just ahead of the worst area that we needed to get through. I told Hawley to wait here and I would run ahead, grab our brother's things, and run back. Once we met up, I would pass the things to him and he could run the rest of the way. We were both exhausted so we knew that it was a good idea. I took off running and it was pretty bad. The wind was blowing the fires from behind Diamondstone straight across the street. It seemed to take forever, and I was worried I didn't have enough energy left. Just then, as if it was meant to be, I saw a beautiful black pedal bike with a baby wagon hooked to the back sitting in someone's driveway. It was sitting there perfectly as if it were placed for me to see it. I was pumped! I hopped on that hot rod and made it to the house. I ran up the steps, booted in the door, and grabbed the treasure. I stuffed the Tupperware containers into the wagon and rode hard back to the firestorm. Through the smoke and embers I could see Hawley waving a flashlight beam into the air. What a beauty — he was showing me the exit through the thick smoke. I blew through the thickest of it and Hawley began to come into view. He was killing himself laughing and said, "Where did you find that?" He hopped on and we doubled back to the trailhead. My legs were absolutely done so Hawley kicked me off and rode the bike back through the trails to the rescue truck. By the time I made it back, Hawley was stuffing the Tupperware bins into the roll-up doors of the truck. Just then our colleague came around the corner and saw that we had completed the mission. Hawley and I saw how happy he was and the spirits of all three of us were lifted way back up. *Steve*

The fire now was now fully involved on Diamondstone Drive. There were a few ARFF trucks ready to stop the fire from spreading down any further. Steve and I were tasked with assisting the operators of that truck. We were performing a shuttle operation — set up hoses on the hydrant, load the truck with water, then repeat. They saved that whole street from being wiped out.

Sackett and I walked over to one of our ambulances parked on the street. Members Ralph, Shantz, Jamieson, and Hurley in the back. Crawford and Townsend brought up an ambulance that was completely stripped of medical supplies and restocked with water and food. Spirits were up, but exhaustion was very much presenting itself on everyone's face. From the driver's seat, Crawford looked back and asked if we had heard the news about our deputy chief of training — his daughter and his wife's nephew had been killed in an accident earlier in the day south of the city while evacuating. Silence broke over the ambulance. We all stopped worrying about each other and our hearts went out to him. *Jerron*

The residential side of the fire seemed to be the real fight at this point. It was a job for heavy equipment. I walked to the light rescue truck and sat inside. In the foreground, city, industrial, and rural pumper trucks were screaming. Generators were running, dozers were knocking houses down — it's too hard to describe what this all sounds like. It is constantly loud. For hours. Essentially, you have large diesel engines or gasoline engines on high idle all over the place. The pumps themselves have a way of screaming when they're working hard. People's houses were collapsing, barbecue propane tanks were blowing up, and people were running around yelling things at each other. The guy in the driver's side was John Gillies, another Afghan vet in the department. There was a silence between us. I broke it abruptly with "It's official, this is Afghanistan." He laughed in agreement. Pumper trucks had now pulled away from the green space and positioned themselves on the street. Gillies and I helped tag a hydrant and send water to a truck.

Internally I was sad during Prospect. I tried to hide it as best I could. I often wonder how well it worked. During the more mundane tasks, my mind started to wander. I began thinking about all the things I had done until now — I was twenty-nine. Every physically and emotionally exhausting endeavour I had ever endured felt like it had finally caught up to me. I could see it in other guys in different ways. I think of Jerron on all fours staring at the ground, during the chaotic beginning to the Prospect fight. I was standing beside Joe Jamieson, who was watching Jerron. Joe was my preceptor when I was in college doing my ambulance practicum on the department. He really took me under his wing and from his example I learned how to manage 911 calls — how to act, what decisions to make and when. Now he looked at me with a small smirk and was still able to convey sincerity when he asked, "Do you think he is having a jammer [EMS jargon for heart attack]?" What he was really asking was "Is he okay?"

I kept my eye on Jerron until he stood up again. I wondered if he had just had the same internal realization I did during Prospect. *Graham*

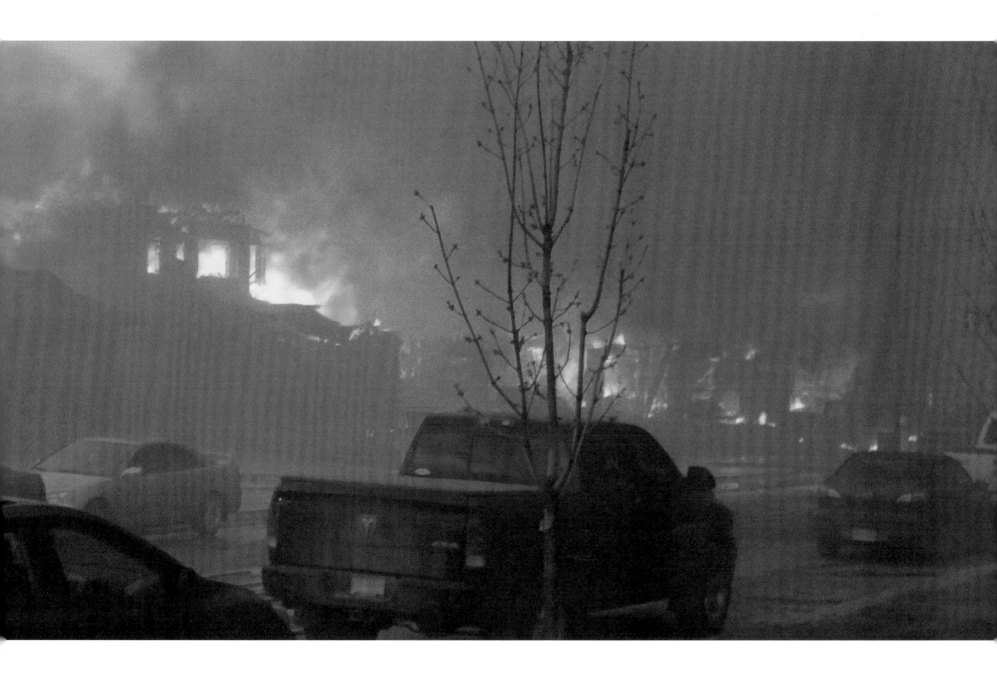

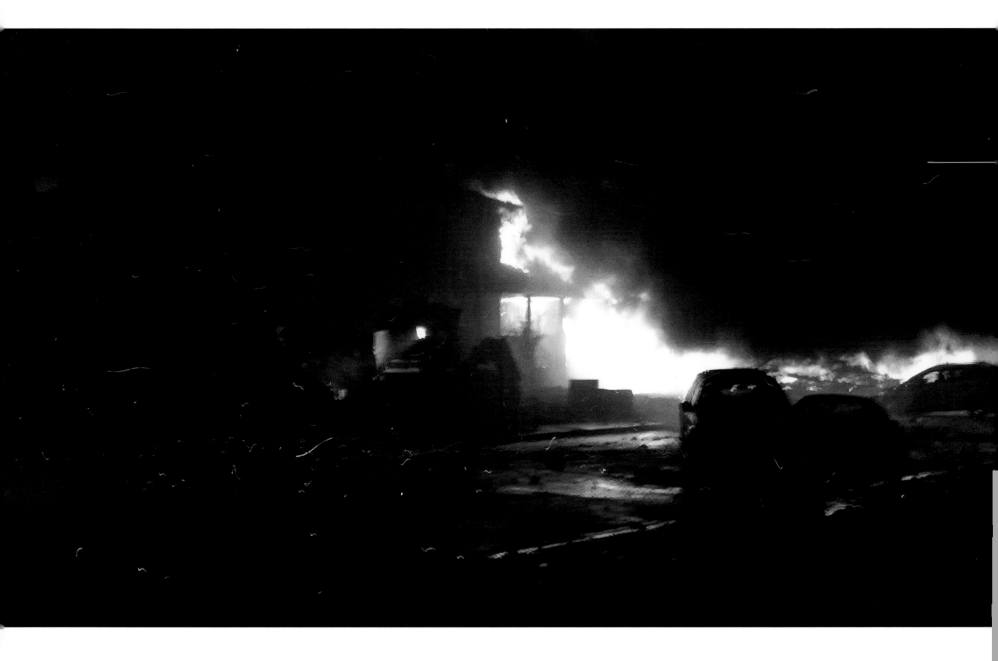

Embers were flying higher and faster over our heads just looking for areas to ignite. The heat of the fire coming from the houses just a couple of yards away was making the night setting feel like day. The once-dark skies were now being overpowered by the orange and yellow glow beading all around our city.

We were standing on the top hill of Timberlea and looking across the tree line to the southeast side of Fort McMurray. It was on fire for as far as we could see. It was never-ending. It was literally burning all around the city as if the fire were a doughnut and Fort McMurray was the centre. It was gut-wrenching. We were all standing, staring, and wondering the same thing. At what point would the fire win and we evacuate? One of our guys asked the question out loud: "How much more do we fight before we pull out?" followed by a few comments of "What if we get trapped?" until one of our members calmed everyone down by saying, "They aren't just going to let us die here, we're not going to die here tonight, fellas." *Jerron*

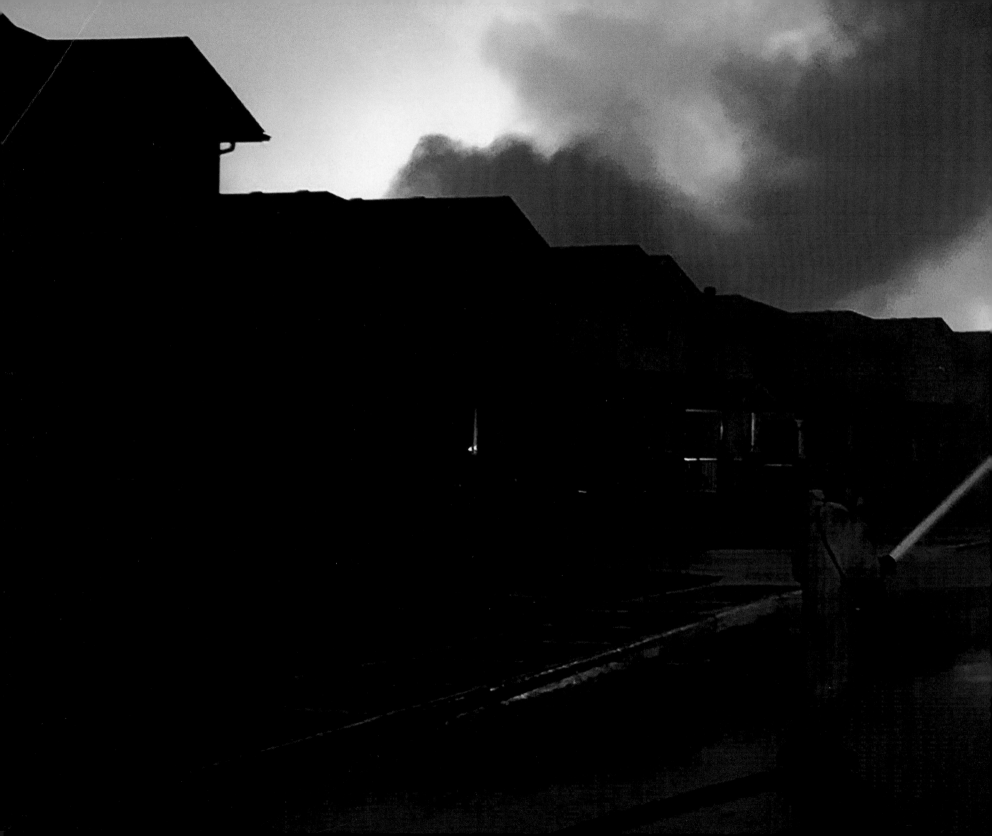

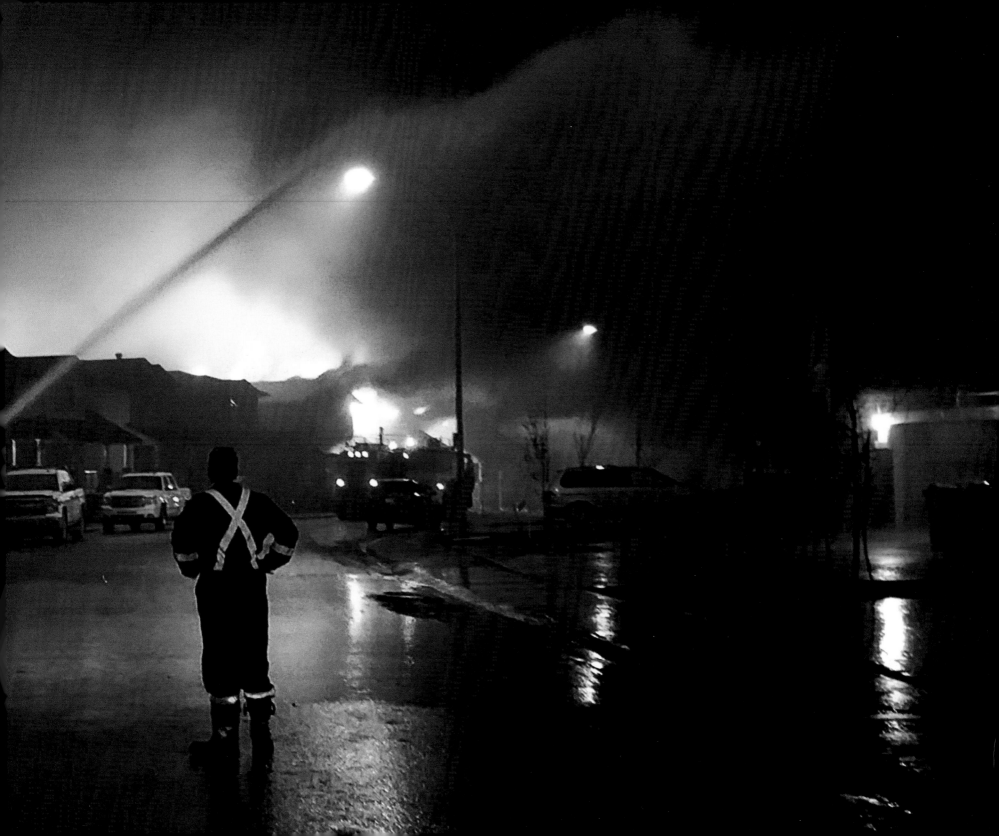

While we were down on the opposite end of Prospect, there was a decision made that essentially saved the fire from advancing any further. Bulldozers were sent in as a last resort, demolishing houses that were untouched by fire but alongside houses that were burning to the ground. Fire can't burn or spread without fuel: take away the fuel, you take away the fire. The operators of those bulldozers deserve a ton of credit. They were working while fire was breathing down their necks, so much so that the rubble underneath their machine was catching while they were working.

As a bulldozer cleared the last house on that row, we were seeing the winning side of the fight for the first time that night. There was still a lot of work to do, but the fact we didn't have to back up every ten minutes to make a line was a huge sigh of relief. I take out my phone as things were "calming down" and captured what my eyes couldn't believe they were seeing, a whole area where buildings and houses stood was now replaced with molasses-thick smoke and embers circling around in tornado-like fashion. *Jerron*

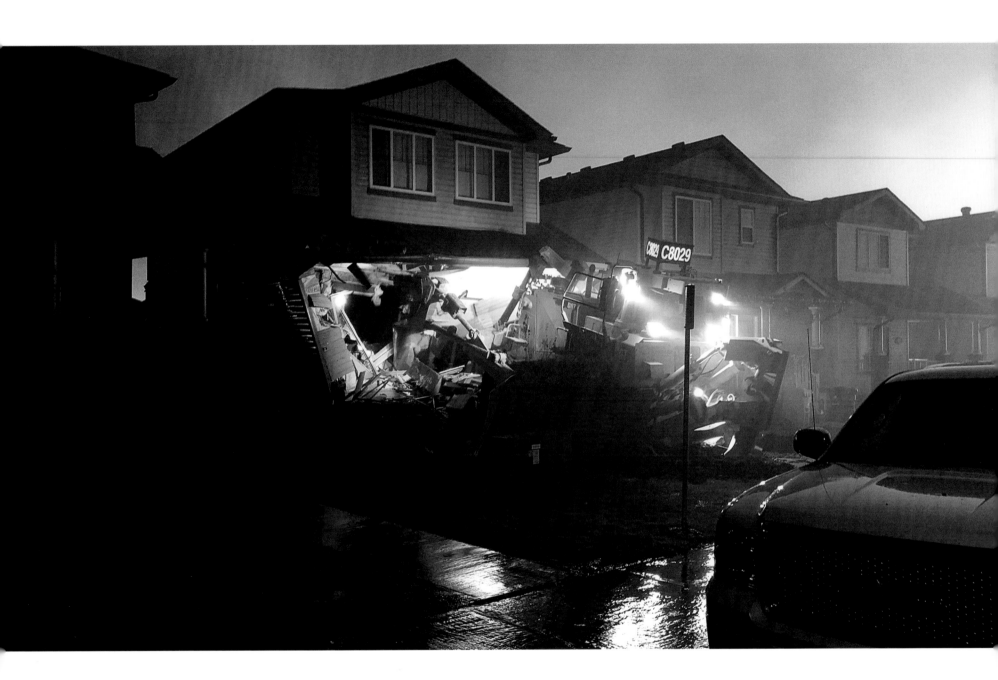

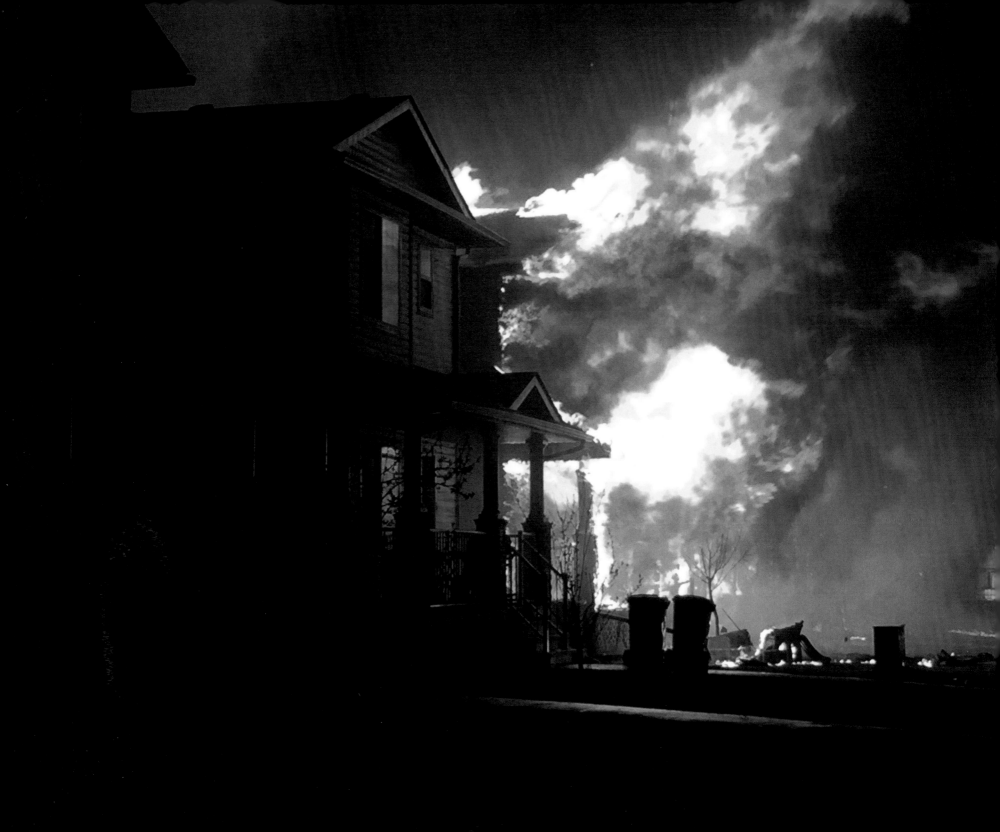

We flagged down a pickup that was heading up the hill. We drove up the empty smoke-filled streets to the top of the hill for a view of what we had been working with below. What we saw was straight out of a movie. We took a moment to soak in the scene. The noise was incredible as the fire tore through homes and constantly blevied any propane tank in its path. To our north the scene was apocalyptic. Homes razed to the ground by the dozens, still raging in flames, the heat waves distorting the view. To the west, a crew had a pumper set up. They were dousing an exposure which was next to a fully engulfed home. To the east, across the street, dozers and backhoes were smashing down lit houses to create a fire break between us and hell. Firefighters were putting out fires with hand lines then momentarily turning back to spray the heavy equipment working in the flames. To the south, pumps lined up down the street, blasting homes and protecting the homes on the next street.

Steve

The Prospect fight seemed to be winding down. It was thanks to all those amazing people digging, humping hose up and down a steep hill, cutting down chain-link fences, getting soaked from sitting on a hose line, all of it in the dark, covered in mud. No one complained. Everyone knew what to do: fight fire or at least do all the things that make it possible for other crews to fight fire. The fire hadn't changed. But the men and women on the ground had seemed to.

Eight of us hopped on to the light rescue truck, with me behind the wheel. I pulled forward and was on the move to Mac Island, which was now being called "staging." It was something to take in. The freeway was abandoned. I drove faster than I probably should have, especially with five guys hanging off the outside of it, but there was something so freeing about the reckless abandon of it all. It was a moment to relish. It was the first time it felt like we owned the city. *Graham*

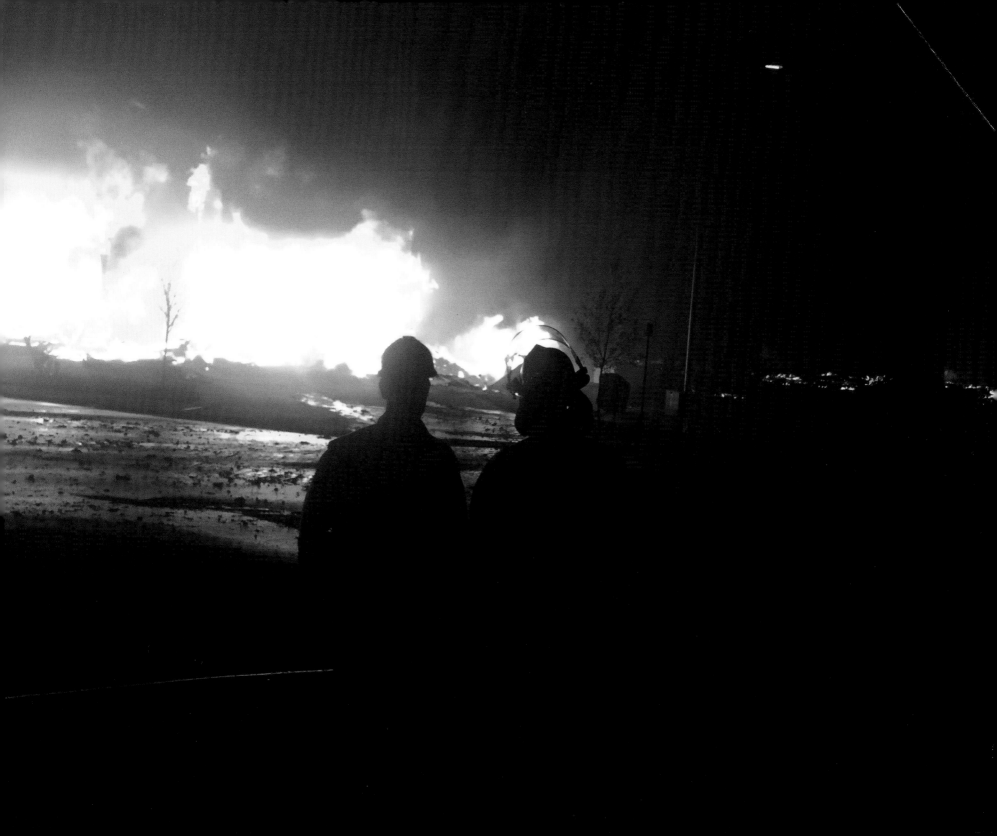

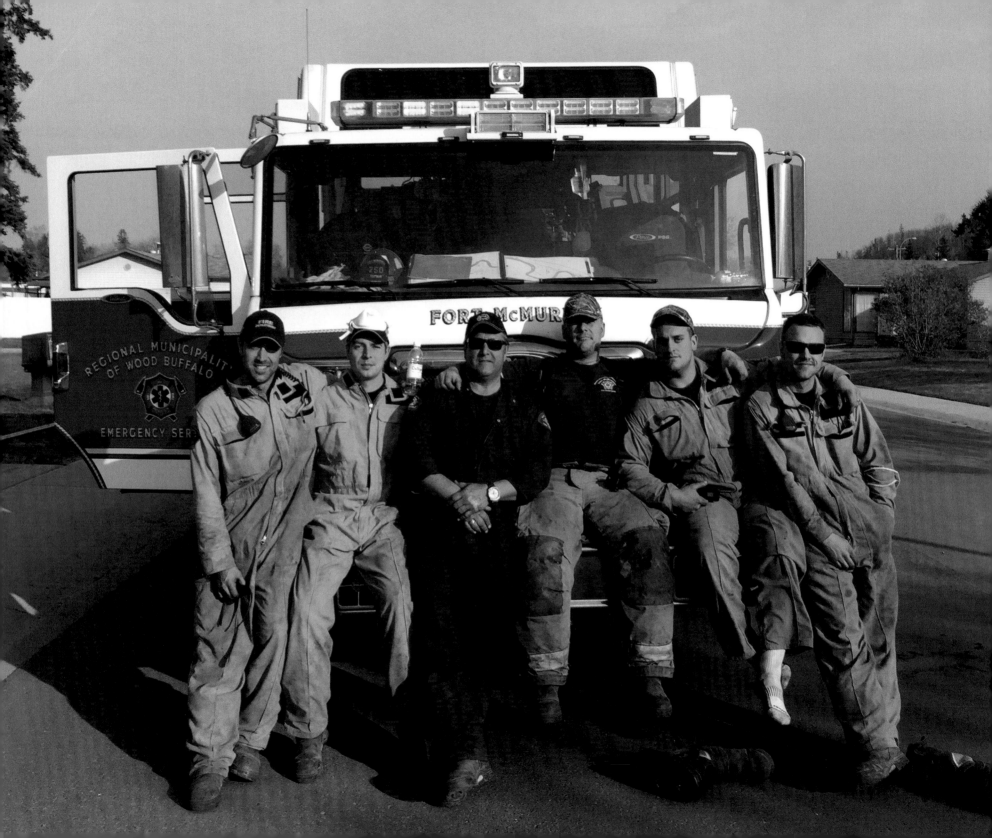

Mac Island

When I saw Captain Pat Duggan in the morning, I asked, "Did you sleep yet?" He replied in a whisper, "Yep, got two hours." I said, "What do you need?" He replied, "A pump operator and a grunt." I walked back into the curling rink where our army cots were and came across Sackett and Hurley waking up. I told them what Duggan needed, and we headed out to the truck. We loaded it up with coolers full of water. We ended up with the self-proclaimed "Warrior Crew" of Duggan, Sackett, Noseworthy, Hiscock, Hurley, and me in a five-seater pump truck.

We drove around town seeing the affected areas. It was only when the fires and smoke cleared that the destruction became visible. Not many words were said during that drive. But in the back of my mind I could think of only one thing – everyone got out safe. During our short drive, we were assigned, and we headed down to TaigaNova Industrial Park near Highway 63. As the fire on the hill behind it started flaring up, we arrived at the scene and were met with Pump 5. Both teams started unloading equipment and attacking the fire. I saw the fenced-off area behind the Praxair building – it was filled with compressed cylinders that had everything from oxygen to propane in them. I told Duggan about my concern and that I would be able to most likely find a forklift in their building to start removing them. He gave me the Knox-Box keys, which would open any industrial door in the city. I took Hurley with me to start looking in the attached building with multiple storage areas. I tried the first one – no luck. I came back to check up on Hurley. He'd found a forklift and had it started but no idea how to drive it. Sackett walked in behind us, so I left them there to figure it out as I went to check the last store

Left to right: Steve Sackett, Adam Hiscock, Doug Noseworthy, Pat Duggan, Jerron Hawley, Graham Hurley.

in hopes of finding another forklift. Bingo. There it was – a fully operational forklift that . . . I had no idea how to drive. I decided that if the operator at the local lobster pound back home in Port Hood had no problem with his, I could figure it out. I hopped on, searched for keys, found them. Started it up, pulled some levers, this does this, that does that – bingo. I opened the bay door to start doing the job. There was one small "bump in the road" – the loading dock for all the equipment was meant for transport trucks and there was a four-foot drop-off holding me back from getting to where I needed to go. Then I saw Hurley ripping around the corner and starting to pull away crates of cylinders. I had one choice and that was . . . forward. I backed up and drove as fast as that propane-powered machine could go and launched into the air, hitting the ground hard. I wish I had footage!

After basically taking a chapter out of the *Dukes of Hazzard*, we refocused on our job: removing potential bombs. We got around thirty cases out onto the street when my forklift ran out of fuel. Hurley got out of his and gave me the reins saying, "You're more useful," although he had done a great job. I started up again, knowing there was only one case left and there was still a lot of work for me to do, and I heard an engine roar around the corner. It was Sackett – he had found a zoom boom that looked brand new and was coming in for support. The guy says he never drove one before but he could start his own business after what I saw. —*Jerron*

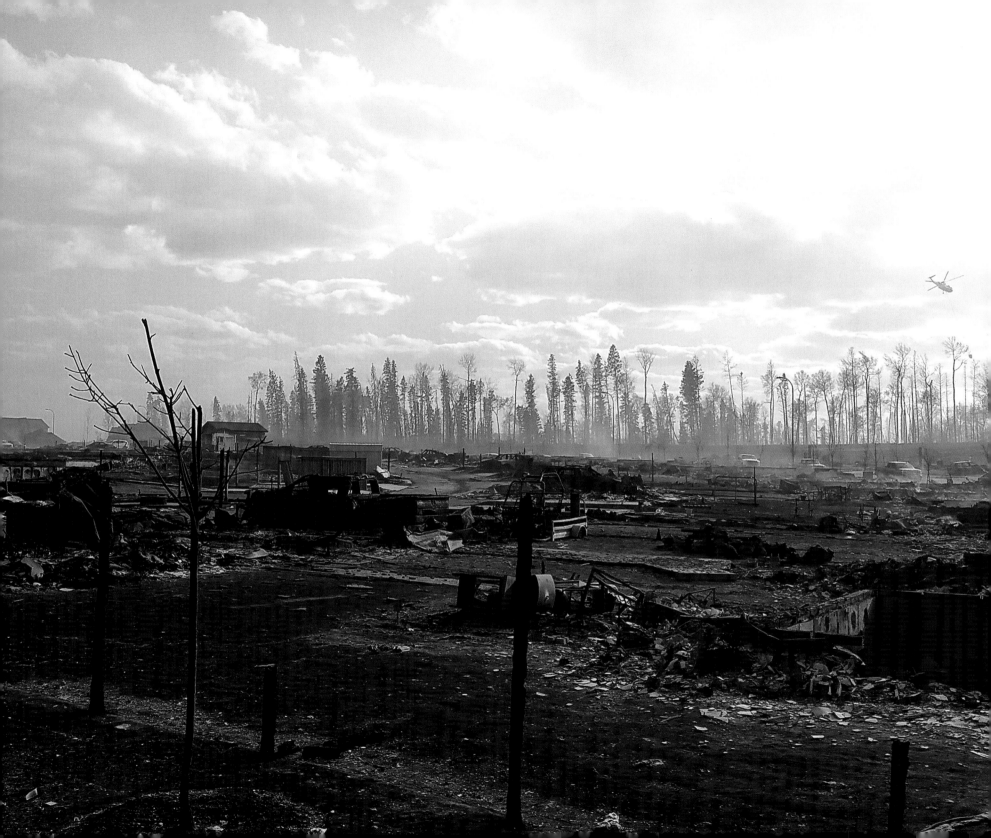

We drove down Real Martin Drive and saw the devastation. The fire was now being held at bay from the battle the night before. We saw the line our men and women held and the houses they saved, but row after row of homes were gutted down to only their spalling foundations. We drove around the east side and found burned hose where our boys had had to back out in a hurry; abandoned tools and saws were piled up, waiting to be picked up and put back to work. We ran into the RCMP, who were doing the painstaking work of documenting each home in the city.

We heard reports of hotspots flaring up along the tree line behind Signal Road so we redeployed in that direction. On our way, we came up to forestry lines spread across Signal Road from pumps feeding the sprinkler lines that we had set up a day before. Someone had driven over them and the connections were broken, spewing water out of the pump. We stopped and shut the pump down, drove over the pressured hose, stopped the tires on the hose, effectively crimping it, and repaired the connections. We did this two more times down Signal Road.

We decided we needed real food so we turned into Thickwood Safeway. Duggan opened the store's doors with our Knox-Box keys. We walked into the grocery store and it was like heaven. All the food you could ask for — the power was still on and not a soul in the store. "Take what you need, boys," Duggan said and we did. We each grabbed what we could and made our way to the till. We wrote down every single item and left the list for the store manager. While we were doing this, Hawley pointed out the song playing over the store's loudspeaker — Adele's "Set Fire to the Rain." *Steve*

Later on we were told a fire was coming back towards us and fast. I could hear the fire coming in on the east-facing tree line off Signal Road but couldn't see it. It kept getting louder, crackling and roaring and moving with speed. All of a sudden, it blew out of the north-facing tree line, sending flames over the tops of the tree line. It blew out and puked its embers straight north, dropping them on homes and yards for blocks across the road. Now the hunt was on. Spot fires started on lawns and quickly spread. Crews were in and out of backyards, down back alleys, stomping, spraying fires out all over the place. I met back up with Hawley at this time — we were on a mission to fight the enemy. It was how I imagine a fight in a town at war to be. Our eyes were on super-scan, looking for eaves starting to smoke. Then we would come onto another street and find another crew fighting a house fire.

Once we got all the spot fires mopped up and things slowed down temporarily, we continued working deep in the trees, digging out hotspots and soaking them.

We ran 150 feet of 65-mm hose into the bush and then y-ed it off to another two lengths of 100 feet of ¾-inch forestry.

After a couple of hours in the bush, I walked out in the street; up in the sky coming from way up north was the biggest plume of smoke I had seen yet. The plume was billowing white smoke into the atmosphere and drifting towards downtown. It looked like a volcano had erupted and I thought the worst. We had heard rumours that Syncrude or Suncor were on fire. I had no idea what kind of hell that was going to bring with it. In my own mind I thought the smoke was heavy unburnt oil fuel from an explosion at the plants. I wondered if it could be and what would happen if it settled in the valley and ignited. That plume of smoke took away any hope I had of us saving the town. I let my mind wander and briefly questioned what the decision makers — who had relocated to an area outside of town — were planning. I knew I shouldn't be thinking this way; it's a downward spiral once you start thinking negative. **Steve**

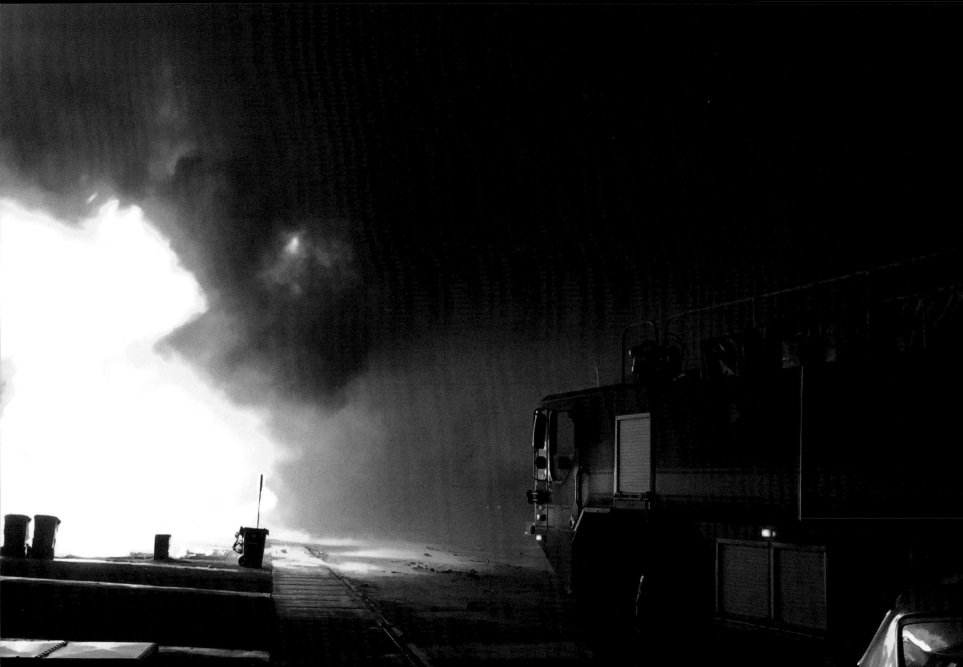

The sun was going down but it was already darker than it should have been. The entire lower townsite backs along the Clearwater River Valley. The fire was now moving along the back side of it. It was nothing but orange and black. Embers were floating everywhere.

We moved into the Mac Island golf course. The idea was that we had to get as far north on the lower townsite as we could to check for any fire extension across the rivers. The mood in the pump was tense. *Graham*

We fought hotspots till the night crept up on us, then attempted to find more. As we came down Thickwood Boulevard, we could see the whole top of the tree line engulfed in flames across the hill on the eastern side of the Clearwater River. The fire was moving towards Mac Island and downtown. For the first time I felt immediate fear and said to Graham and the other guys in the back, "Guys, we shouldn't be here." We all had our eyes locked on the fire approaching the city. We drove right into MacDonald Drive, rushing towards the kilometre-wide flames that threatened to breach the Clearwater River, in order to prepare to make a stand. We burst through a municipal chained fence that bordered a walking trail and drove down the path with thick trees and bush on both sides. This is where reality set in. I said, "Captain, this is a bad idea, I don't think this is a good idea." When we got to the northern tip of Mac Island, I looked at Graham and he had the same fear on his face. If any of this side of the island caught, we would be stuck in the middle. The fire was torching like it was in Timberlea fifty feet across the river. It was looking to jump to our side and cause havoc.

We began looking frantically in every direction for anything that could catch fire. We knew if it did we would be dead. A few started to panic and get angry — why were we in this death trap and why is there no water source? Sackett spoke to the crew while Duggan went searching. Sackett asked, "Are we all sticking together?" Those words frightened me and immediately made me think of my family and of Carlene.

We saw that the fire was starting further south on the island towards the main building and driving range. We hopped in the truck and drove over. By this point, the fire had reached the shores of the river on the whole east side around Mac Island and was just looking to jump the river. Hurley, Noseworthy, and I for some reason started walking towards that side. We were looking for cars or carts that could be our getaway. Panic was still at a max. Then over the radio I heard Duggan: "Guys, back to the truck ASAP." Duggan never says ASAP. We all sprinted, running like we never had before. Once we arrived back at the truck, he informed us the fire was now coming down the south side of downtown into the city core and we had to protect our city. Just before I hopped in the truck, I ran over to the practice putting green beside our truck and grabbed a golf ball. At the time I thought it might be the only memento I'd have of the building.

We drove to Prairie Loop Boulevard, the whole way watching the tidal wave of fire coming over the hill and down towards us. Everyone in our truck was stuck staring into the fire on the hill. Sackett, who was driving, hit the curb. I got out my phone and told my family I was okay, I was safe, and I loved them. I honestly wasn't sure this time if we would be getting out. We raced over to the corner and were the first unit on the scene. We set up a line facing the east and the raging fire and we waited.

Duggan got out of the truck and walked over to the second incoming truck, and they headed down to the shore about a kilometre away from the road. It was a wooded area, just one of the many spots that, if it caught fire, would threaten the city. They walked right into the woods. Our crew was ordered to stay back. I was still locked in panic — this is when I feared the most for our safety. I sent another message out to my family group chat, and my brother Loren replied. Then for whatever reason, it hit me. I realized that my family was all safe, and that's all that really mattered. *Jerron*

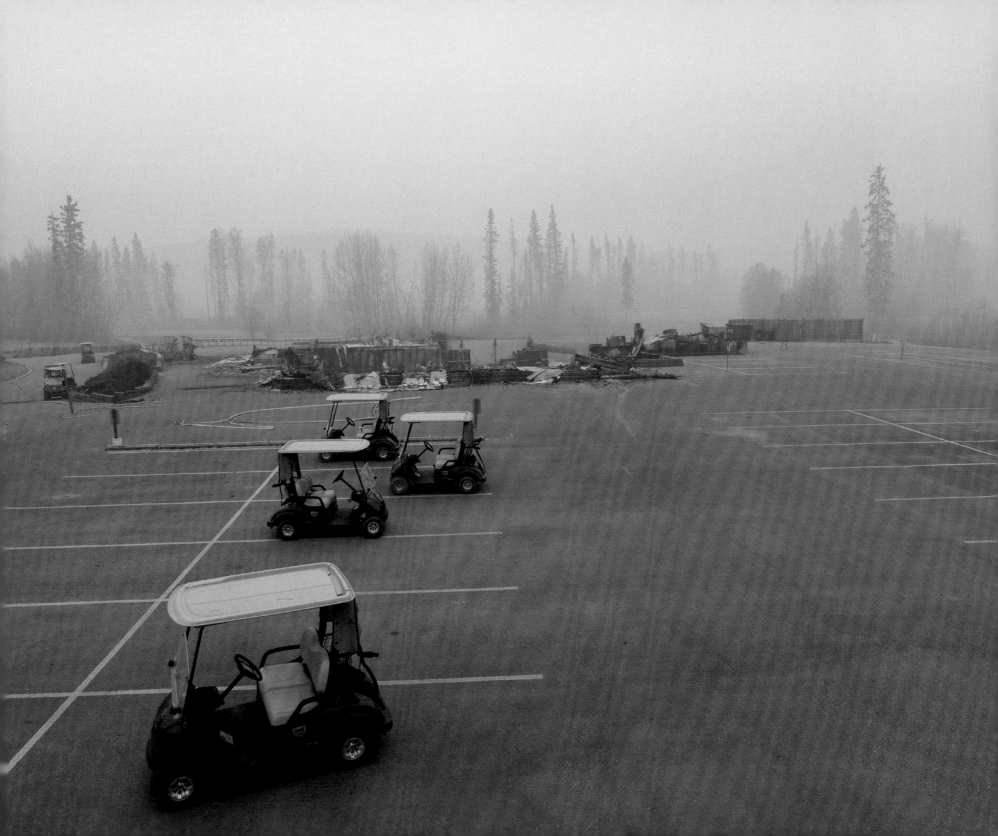

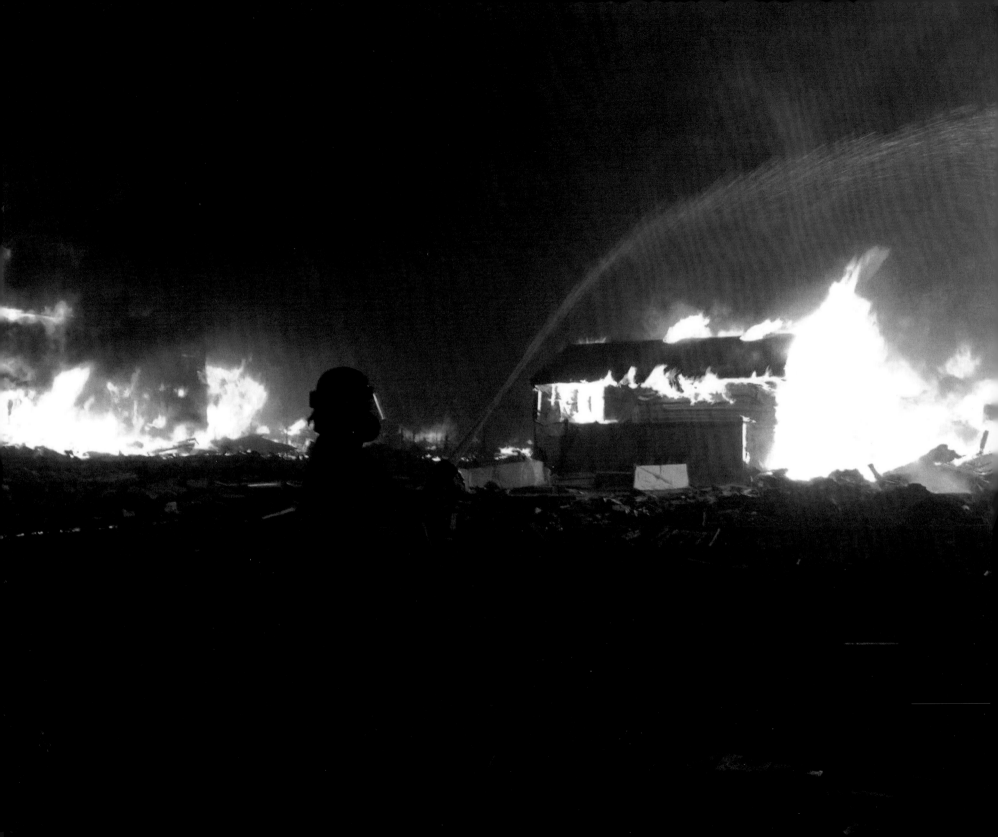

We had only one option — to keep going forward as a team and beat this. I got other departments listening to the needs of our crew. The winds shifted, pushing the fire back east, and giving us the chance we needed. An FMFD pump needed hose run down to a wildland pickup that was heading right for the heart of the fire. Hurley, Hiscock, Sackett and I grabbed handfuls of 65-mm hose and just started running. We laid out 1,000 feet of hose, moved a fence and propane tanks that were in the way. We muscled our way through the thickest trees and bush and knocked down the fire. We stayed until the hot spots were out. We finally got to say hello to the FMFD pump in front of us and gave them a typical war zone smile of relief. *Jerron*

The fire had retreated to the east and continued to go that way, burning up buildings at the airport. It then worked its way into Saprae Creek and took many homes out there. It touched the community of Anzac and continued to burn the forest for weeks after, far into Saskatchewan. I have heard reports of that fire and others in the area moving up to sixty metres a minute. How that fire never took Mac Island and downtown is a miracle as far as I can tell.

We had some time to relax on the riverbank and watch that fire slowly backburn itself down the valley and work its way north, finishing off the hillside. The air was still now that the firestorm had passed and there was moisture in the air, which helped dampen the fires. From our vantage point, we watched the boys control-burn some unburnt grass between the river and downtown. Better to control-burn than let embers drop and then burn out of control.

There was an aerial truck set up to douse the flames if the control burn got too big. To make a control burn, the boys would use a drip torch and start a small circle of grass on fire. In this procedure, the fire burns outward slowly in a controlled circle. The main body of flames is pulled into the circle while the lower body of the flames slowly creeps outward, making it controllable. It is an art form and those guys were artists. I was filming it when a tornado formed in the circle, sending a finger of flames and smoke licking across the ground.

We humped over a thousand feet of 65-mm hose down into the area of the forest that was still burning. Our lines were run off Mark Pomeroy's pumper truck, which was supplied by tanker trucks. We then split that line off into a smaller forestry line, which is easier to pull through the bush.

We worked for a couple of hours knocking down the flames. Stubborn fires were burning high up in the old dead standing trees. Those are called snags and quite often break halfway up and smash on the ground. Our heads are on swivels when we are working in the bush because of conditions like that. **Steve**

Finally we called it and re-racked our hoses and tools. We were bagged, I could hardly see straight. Hurley's house is in Saprae Creek and it was killing him not knowing if it was gone or not. We talked about it and decided to make a run to Saprae. Without hesitation, we were all in. We stopped in at Hall 1, grabbed some fuel and coffee, and hit the road.

As I drove, I was trying to keep my mind together, but I was so tired that I missed the turnoff and had to back up to make it. The street lights were out, and we were going through heavy, thick smoke.

We pulled into Saprae Creek and the first stop was our colleague's friend's house. It was gone. I turned my scene lights on and we took some pictures. We backed out and journeyed down to Hurley's place. Houses were burned up along the way. We pulled into Hurley's driveway, and his house was still there, standing tall.

The RCMP pulled into the driveway to find out what we were up to. You could tell by the expression on their faces they knew we had been through the thick of it. They wished us luck and disappeared into the smoke.

Going back to town, the drive was long. I was doing everything I could to keep the truck on the road. The streets were eerie. It looked like zombie land, with no one on the highway except emergency vehicles, fuel trucks, and water haulers. We drove past a dozer that had fallen into a basement and burned up.

Daylight was close by. We parked beautiful 316 (our pump) in front of Hawley's place, I thanked her for being so good to us, and we went inside.

Hawley was worried there weren't enough blankets so he fired up the ATV and went and got more from somewhere. The gas had been off for days so we had cold showers and passed out. I fell asleep remembering the sounds of propane tanks exploding and wondering if we would be waking up to this house on fire. In the previous few nights I would wake up with the bed soaked in sweat, and this night would be the same. I think it was my body trying to rid itself of the toxins we had been inhaling. *Steve*

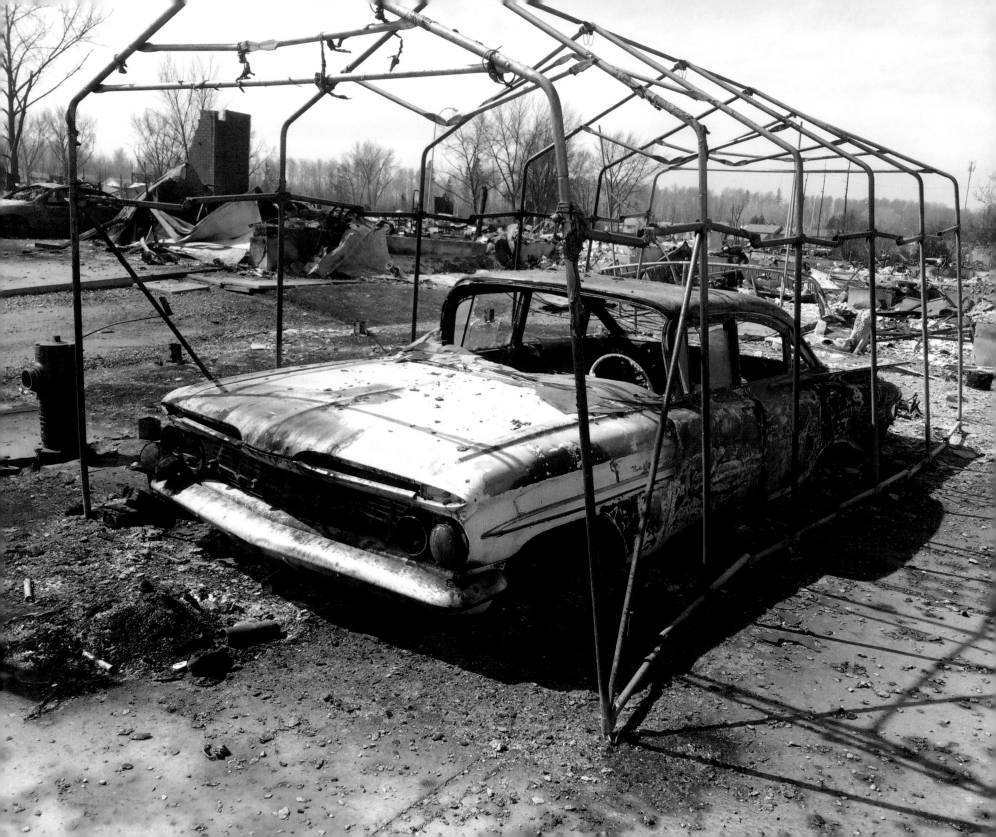

MAY 6
Waterways

Waking up with five hours' sleep under my belt for the first time in days, I immediately call Carlene. I wanted to tell my family about Carlene being pregnant. One by one we three-way called each of my brothers and sisters – I wish I had recorded it. It would be grandchild number 14 for my parents but number 1 for Carlene. We wanted to make her family's first news of it special and decided to wait so she could FaceTime them.

I started in the kitchen and got a well overdue breakfast on the go. While I was cooking, the fellas loaded up our beautiful pump resting outside – it wasn't every day that I had the truck parked in front of my house! Our supplies were running low, so we collected a few items from my garage, like shovels and bottles of water, then we were off. In Waterways – one of the hardest hit areas of the city – the legion was basically the only building left standing. Duggan is the president of the legion, and we were met by a fellow FMFD with ex-military on board, and they entered the Legion while we wait outside. A few minutes passed, and they came out the front doors with two large Canadian flags. We attached the flags to the back of our trucks. With our newly modified pumper trucks, we convoyed to Hall 1, flags blowing in the wind. Duggan had grabbed our local union flag along with another Canadian flag to replace the damaged ones on our flag pole at the hall. Both crews, along with a few more members, helped lower the beaten and discoloured flags as the ex-military department members folded them to be disposed of honorably. As we raised the pristine new flags into the air, cheers from our guys and girls erupted across the parking lot. —*Jerron*

It was a beautiful morning, the kind I like to drive home to after my last nightshift: crisp and bright. The mood had changed. At the Legion in Waterways, we attached Canadian flags to the back of our pumps as if to say, we are not conquered. We drove over to Hall 1 to raise a few flags as well. It was a proud moment. We were starting to take the city back. *Graham*

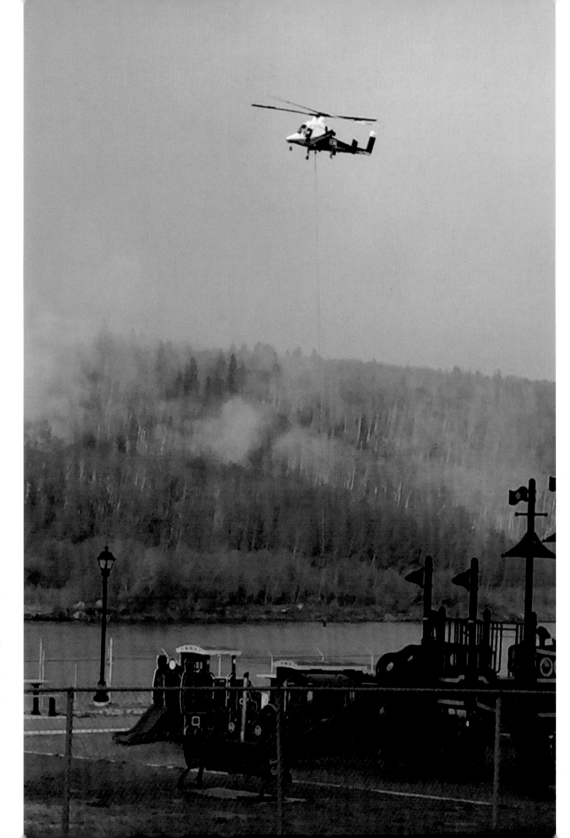

Our first mission was to patrol downtown looking for spot fires and flare ups. We watched three helicopters filling up from the river and knocking down the hotspots across the bank. The helicopters were close enough that we could wave at each other and we did. It was pretty cool. *Steve*

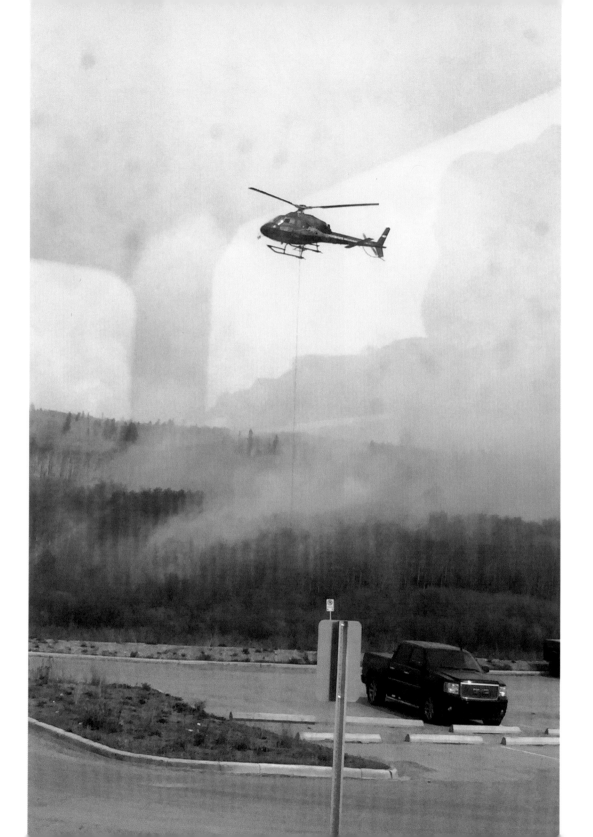

We needed chainsaws — ours were dull and some crews didn't have any. We pulled up to Canadian Tire, used the Knox-Box keys to get in, and took what we needed. We couldn't find bar oil so we went across the street to the outdoor store and tried to find some there. While we were waiting to get in, a homeless man came walking out of the post office. He looked rough and was limping. We filled his backpack full of water bottles and whatever food we could give him. He thanked us and wandered off. *Steve*

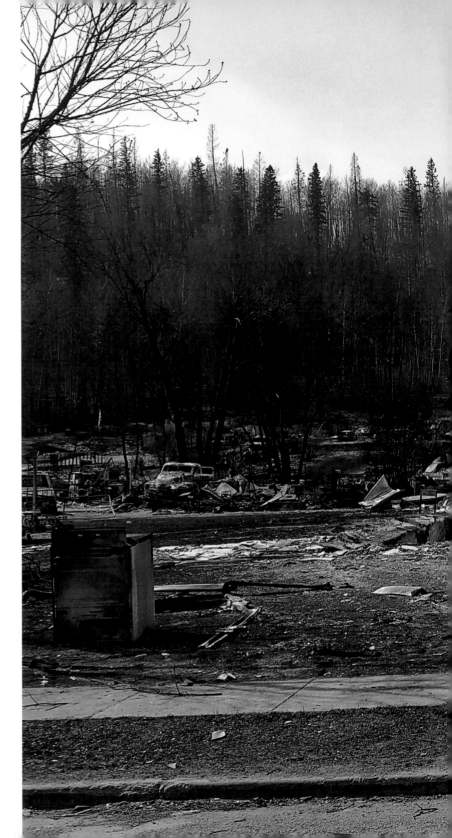

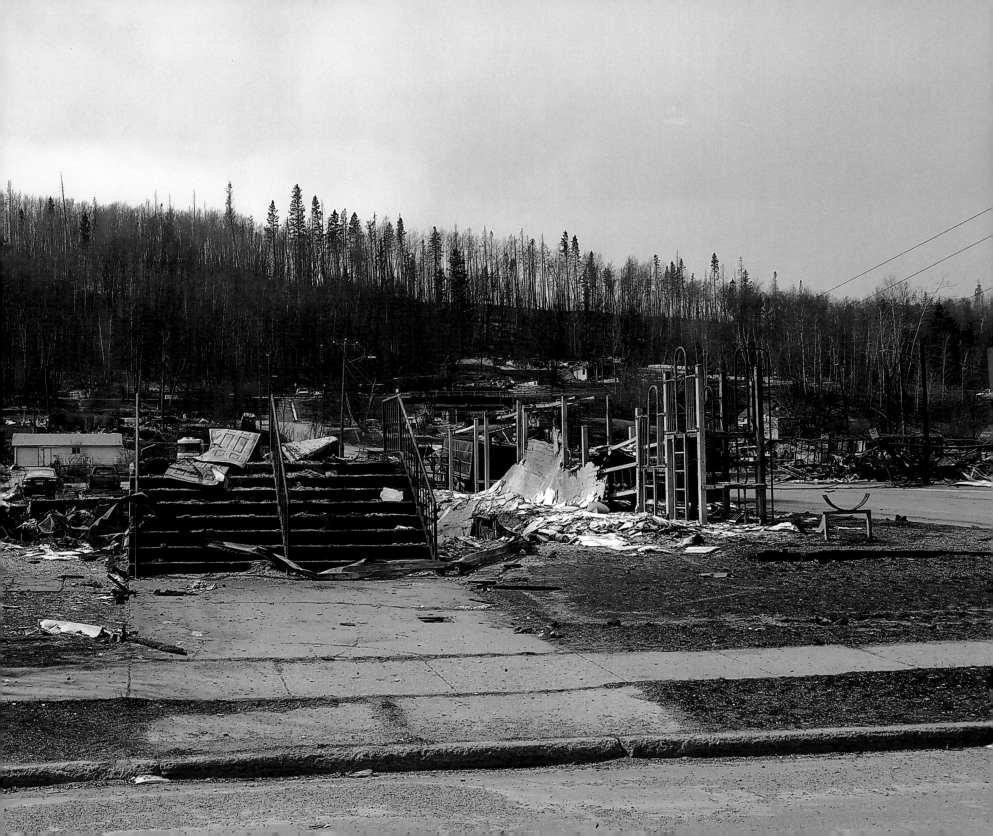

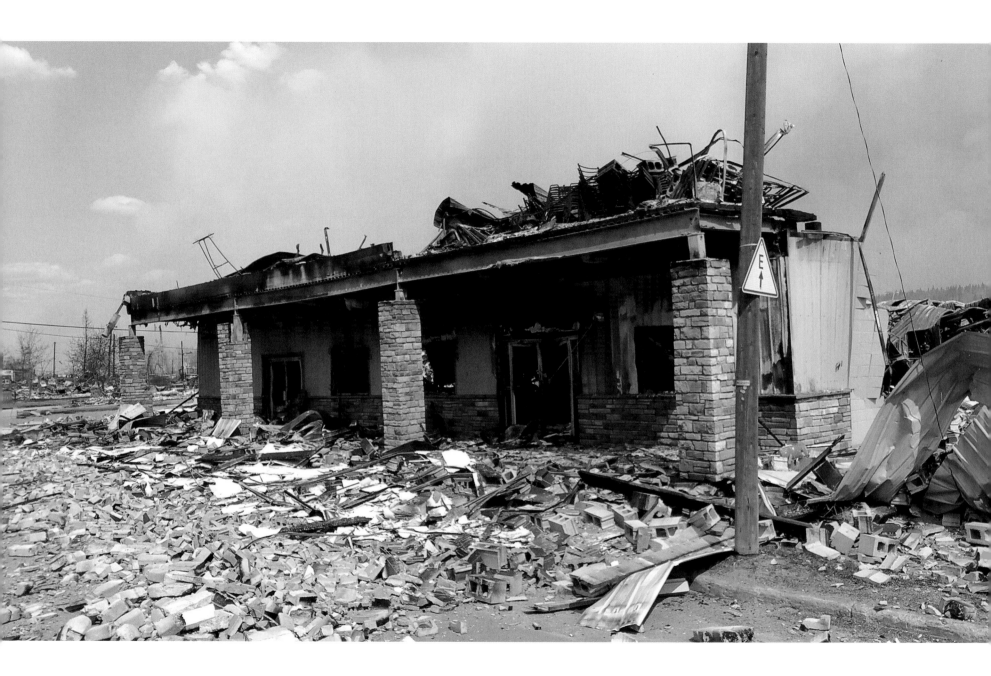

The crews then proceeded to get back to work, patrolling the downtown core for any signs of hotspots or potential fires. It was the first day that was calm enough for us to do so. This is where it felt like a scene from an apocalyptic movie — stores that were normally filled with people now completely empty, abandoned cars in the parking lot. *Jerron*

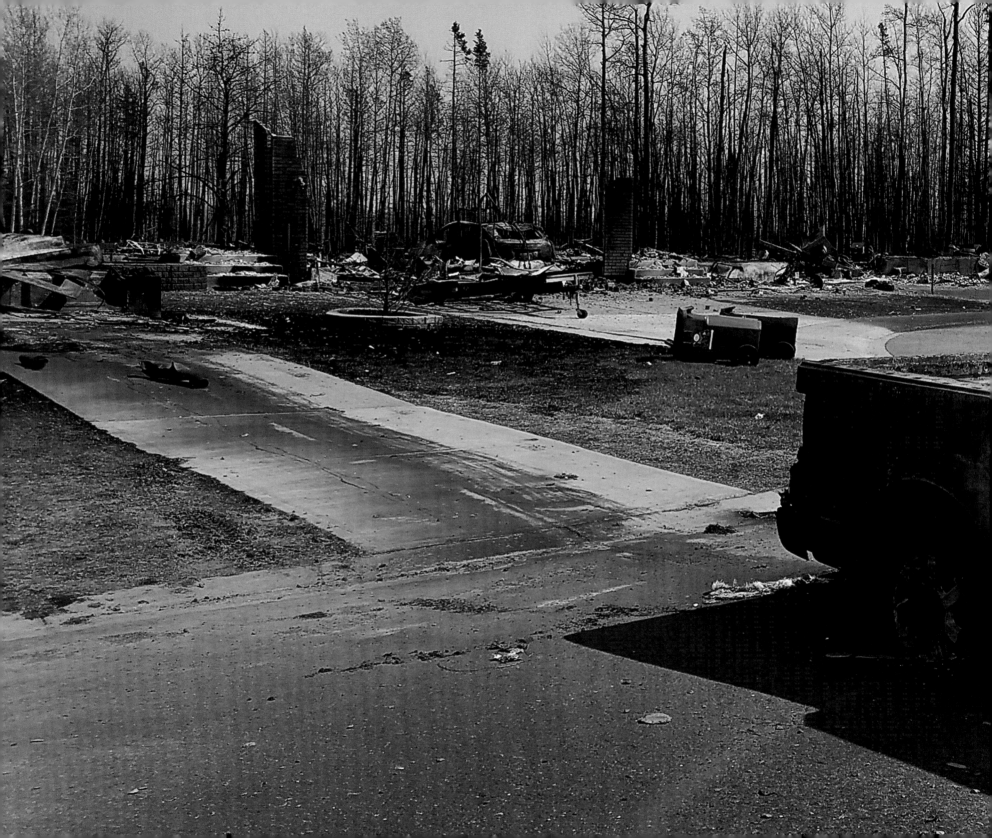

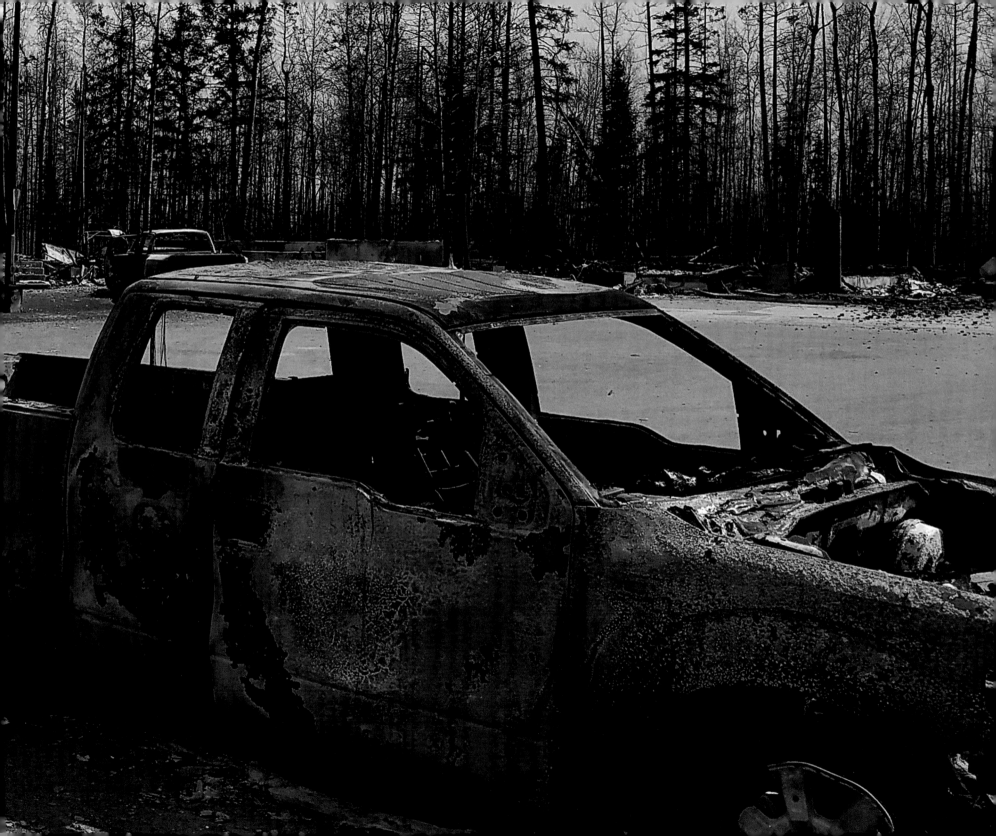

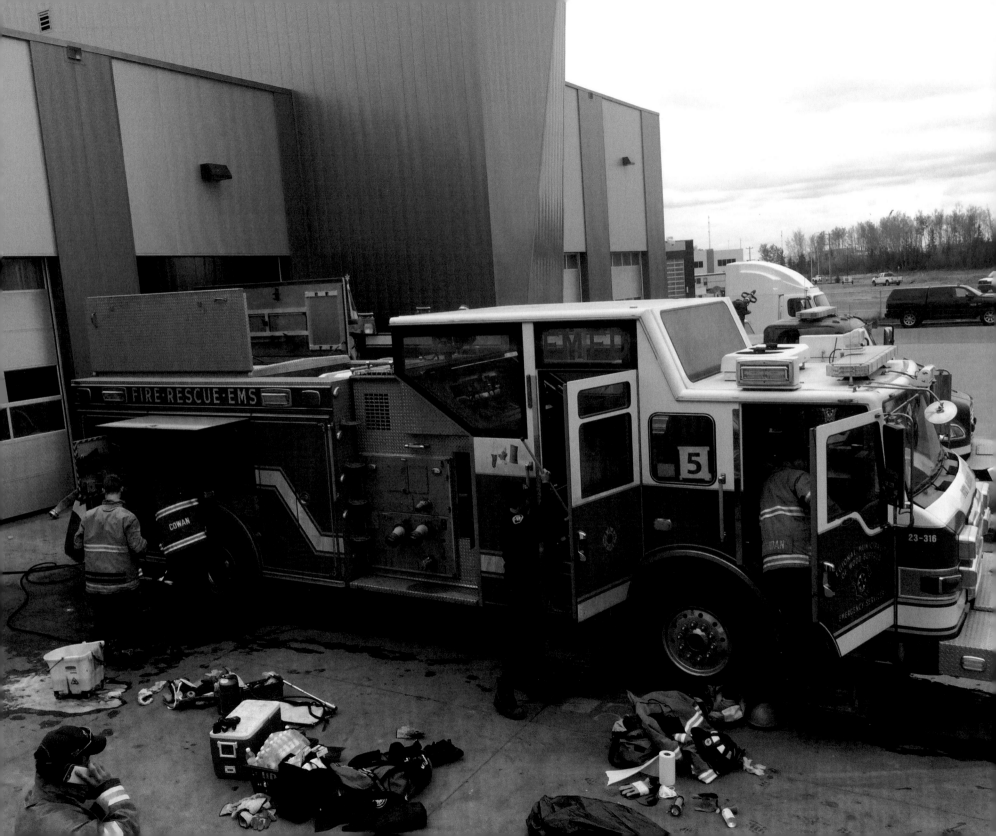

We stopped in and out of Hall 1, doing odd jobs and getting our truck back in order all afternoon. Things had settled down now so the big rush was off. There were a lot of rigs in town making for easy work. Trucks from Beiseker (a village on the outskirts of Calgary) were in town. Some of my crew had never heard of Beiseker before. When they saw the Beiseker members in action, they would say, "Man, those Beiseker guys work like dogs." A lot of FMFD workers had great things to say about the small-town departments that had come to help out. *Steve*

We patrolled some more of downtown and looked for hotspots. There were now helicopters everywhere. Low and close. We made our way out on Highway 69 and tackled a good-size bush fire before returning to Hall 1.

Two guys from the Edmonton fire department, Dan and Cody, came up of their own accord, to help out in any way they could. Cody had grown up with Steve. There are so many shining examples throughout this whole ordeal of people stepping up. This is one that meant a lot to us. *Graham*

That night, I received a few messages from my brother, who informed me of friends and family back home willing to give food or a place to stay. Neighbours I hadn't met before messaged Carlene via Facebook with garage codes so we could get access to them. The generosity of these people giving whatever they could to us was incredible, and we were grateful for it. My neighbours offered their whole house for our members to sleep in. Our crew passed on our thanks to these people as we tucked away for the night with a nice cooked supper and nice place to rest our heads. They might not think they did much for us, but let me tell you, feeding a group of hungry men goes a lot further than you may realize. *Jerron*

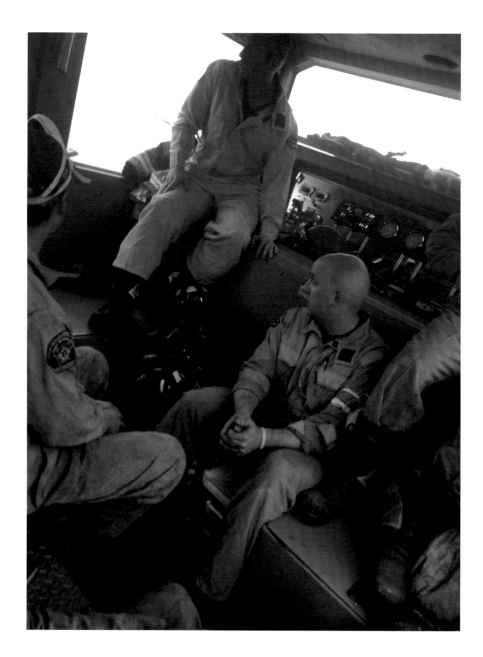

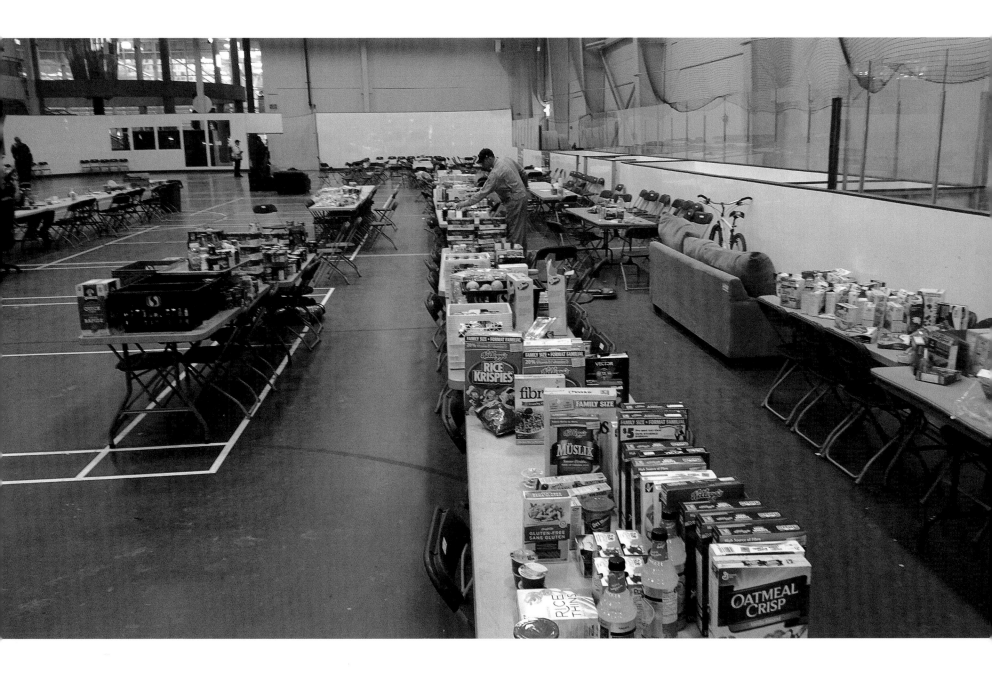

Ottawa, May 6, 2016

N. 952/2016

Excellency,

I hasten to forward to you the message from His Holiness Pope Francis, signed by the Cardinal Secretary of State, after having been informed of the tragedy occurring in Fort McMurray:

«The Holy Father was saddened to learn of the destruction and distress caused by the extensive fires around Fort McMurray, and he assures you of his prayers for all the displaced, especially the children, who have lost their homes and livelihoods. He asks God to bless civil authorities and those coordinating evacuation and shelter for the homeless, as well as for strength and perseverance for all who are battling the fires. Upon those affected by this ongoing disaster, the Holy Father invokes the Lord's blessing of patience, faith and hope.

Cardinal Pietro Parolin
Secretary of State »

In communion with the sentiments of the Holy Father, I heartily unite myself with the confident prayer to the Virgin Mary, Comforter of the afflicted.

With my cordial regards, I am

Sincerely, in the Lord

+ Luigi Bonazzi
Apostolic Nuncio

H.E. Most Rev. Paul TERRIO
Bishop of Saint-Paul
4410, Avenue 51e
SAINT-PAUL, AB, ToA 3A2

BUCKINGHAM PALACE

Prince Philip and I were shocked and saddened by the news of
the wild fires that are causing such devastation to Fort McMurray.
Our thoughts and prayers are with all those who have been affected,
and we send our heartfelt thanks to the firefighters and the other
emergency workers.

ELIZABETH R.

Messages flooded in in support of the city.
Here, a faxed message from His Holiness
Pope Francis, and a statement from Her
Majesty the Queen.

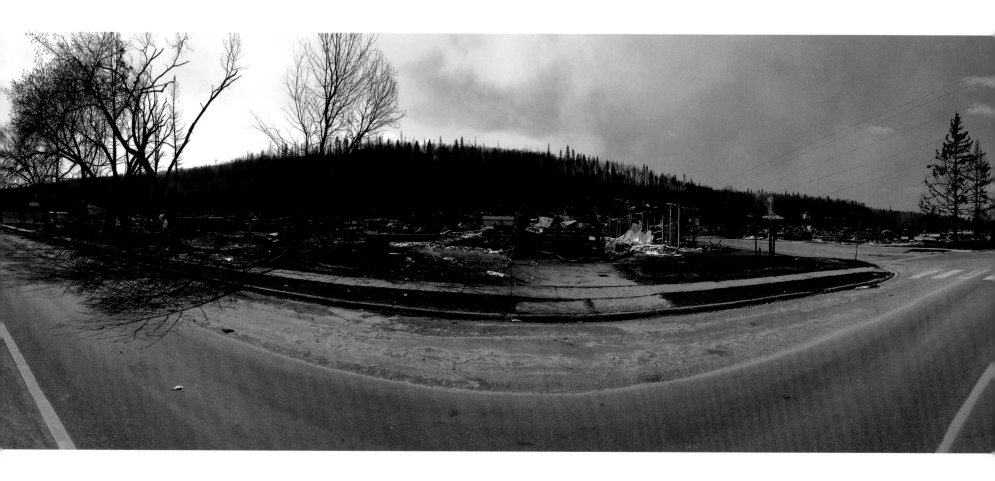

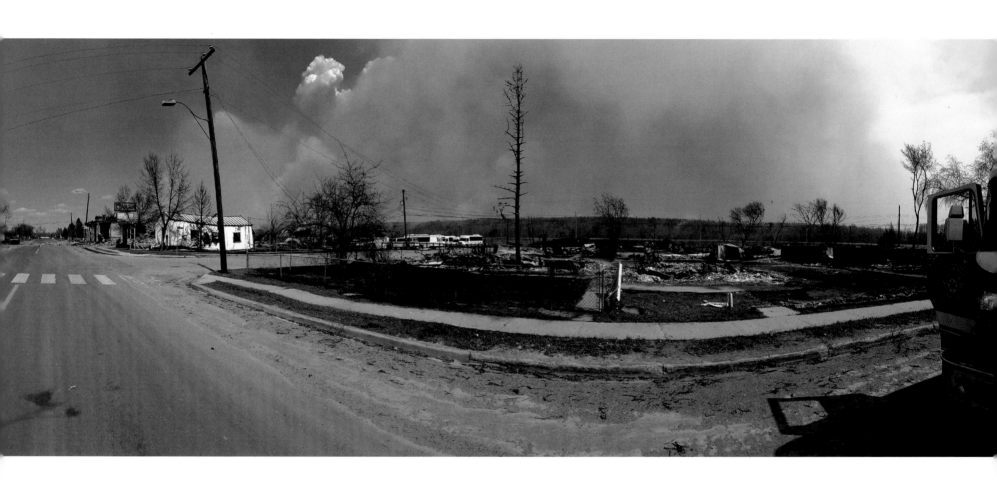

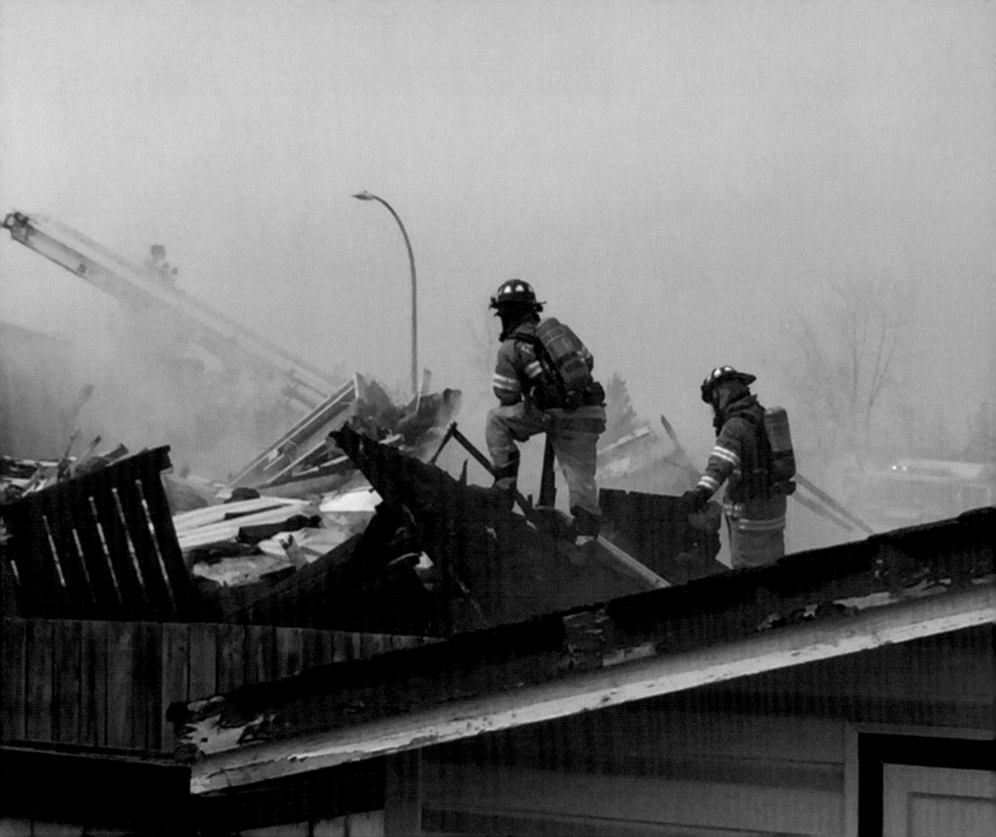

MAY 7
Prairie Creek

We were woken up by the smell of breakfast being cooked by Dan and Cody. They had gotten up before any of us and started cooking a huge scoff. With our tanks now fueled, we started our day by patrolling the city to confirm that hotspots weren't flaring up. The heat from the fire was being held like an oven underneath the ground – although we couldn't physically see the fire, that didn't mean it wasn't burning.

While driving around, we discovered large amounts of equipment on street corners and roadways, with some hoses still attached to hydrants. We collected high-volume hoses, saws, and hose monitors.

With the truck now fully loaded, Duggan suggested we head down to the river. The forests down that side of the city are very thick, with tall trees. As we walked through a small trail, I noticed green fiddleheads growing high as my knees. Fiddleheads are a big deal in Cape Breton. I stopped and picked a few for our fellas to try – a small taste of home.

It wasn't long before our radios were after us for a confirmed structure fire in a subdivision south of the city by Hall 5 – Prairie Creek. We were ready to go. —*Jerron*

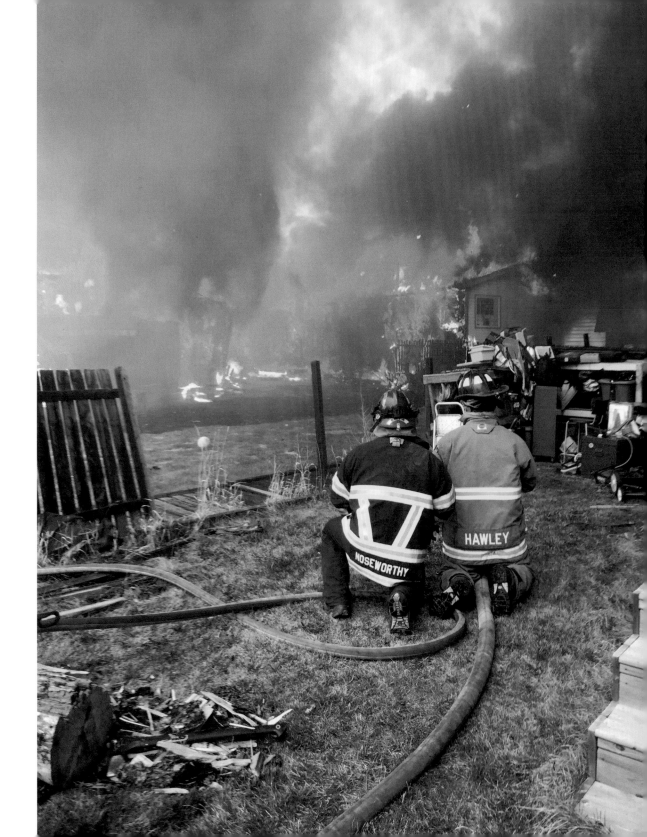

A call came in over the radio that there was smoke showing in the trailer park at Prairie Creek up by Hall 5, just south of the town. Flicked the cherries on, and it was full speed up the hill to the newly started fire. We pulled up on scene to see two trailers burning furiously. The boys jumped out as I came to a stop and immediately pulled two separate lines of 65-mm hose off the truck. One was attached to a monitor and the other to a fog nozzle.

They snaked the lines between the trailers and started to battle. I was flowing water out of my tank and needed to catch a hydrant fast before they ran out. I grabbed the end of the high-volume hose out of the bed of the truck and the hydrant bag. I ran for it, dragging the hose to the hydrant. Dan came across the street to help dress the hydrant. We spun the caps off, set the wrench on the top nut, and opened her up. Six, seven, eight turns on the wrench. No water. Nine, ten turns — I opened it right up. No water again. I was furious, so frustrated to have these fires and not having the means to fight it. In frustration, I grabbed the wrench and flung it across the street. I told the boys on the end of the line to back out, we were running out of tank supply. I radioed Duggan to send me a tanker and he radioed back that one was on its way. *Steve*

While waiting for water, the boys were doing what they could between the trailers, using extinguishers and setting up lines for when the tanker returned. I watched as a helicopter with a bucket came screaming in. "Bird in the air, bird in the air" came over the radio. I warned the boys to watch out as the helicopter came right over top of us and dropped its bucket on the fire, making a dent in the flames. Two more helicopters came in and put a hurt on the flames. Then my tanker showed up and we quickly set up the fill hose in the top of my tank. I was on top of the truck and Cody hopped into the dog house. As soon as the tanker started filling my truck, Cody took the controls and sent water to the boys on the nozzles. It was an awesome feeling to be working with a good friend from home. All the trouble we got into during our youth seemed to be making itself useful now.

Hurley and Hawley were up on the roof of the neighbouring house with a hose line attacking the fire below. We were pumped to be back up and rolling. I grabbed some bottles of water and some Red Bulls and tossed them up. We fought like this for a while; we now had three tankers in line to supply us with water. *Steve*

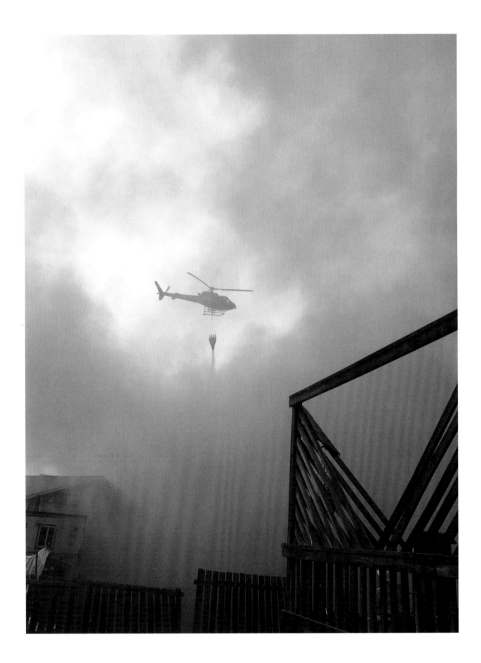

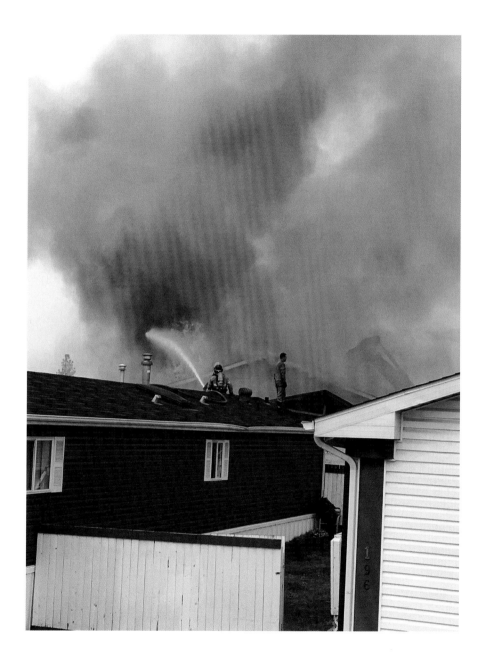

The Shell Albian Sands fire department pulled up with their ARFF trucks and we changed our operations a bit. I was now relay-pumping into the ARFF, and they were dousing the flames with their front-mount turret. I got along really well with Steve, the captain at Shell. We were like-minded and were set up quickly. I was talking with Steve when a dozer came rolling up the street, metal tracks on the asphalt and everything. It sounded like a tank rolling into battle. The dozer was instructed to plow through the fence in between the trailers and clear a path for the ARFF truck to relocate. The dozer started rolling in, onto the lawn, and began pushing.

I had no communication with Hurley and Hawley, and I knew the dozer operator wouldn't know they were on the roof. I climbed up on the roof of my truck and started yelling to warn them. Between the noise of the pumps, dozer, track hoes, helicopters, and the fire, they couldn't hear me. I hurled water bottles until I got Hawley's attention. I pointed over to the dozer but they couldn't see it from their vantage point. They were looking at me, wondering what the hell I was talking about. I started making motions like Frank the Tank from the movie *Old School*, jerking my arms back and forth as if I were driving a dozer. They got the drift and bailed off the roof in time. **Steve**

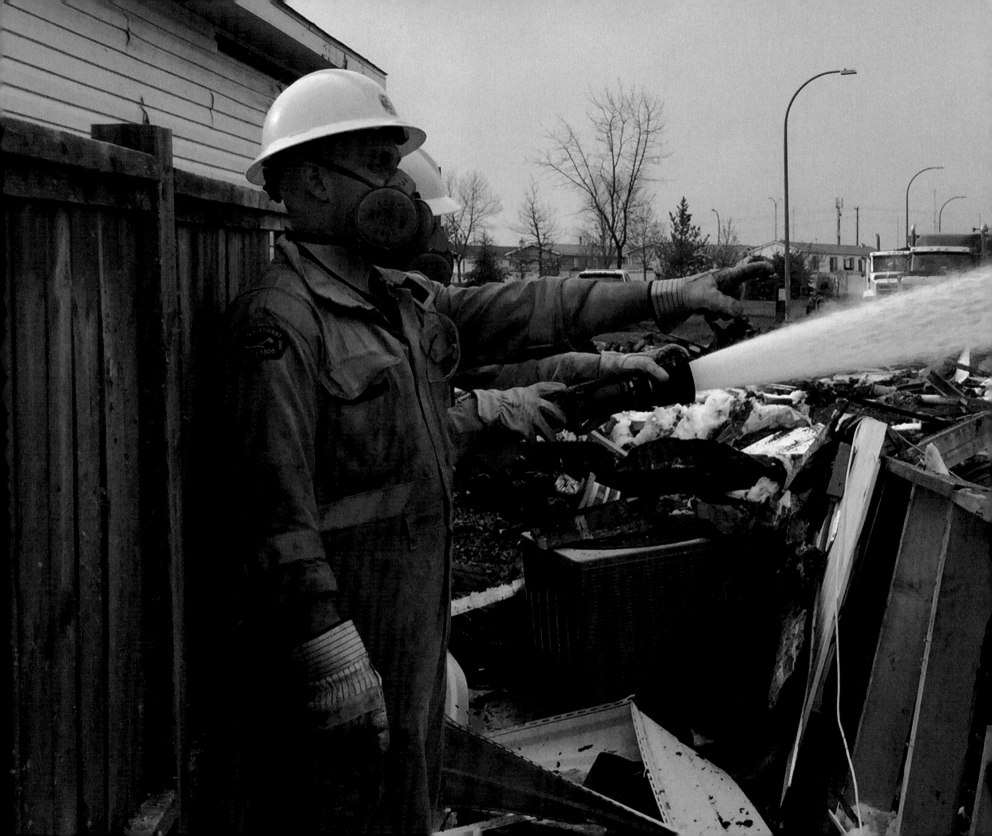

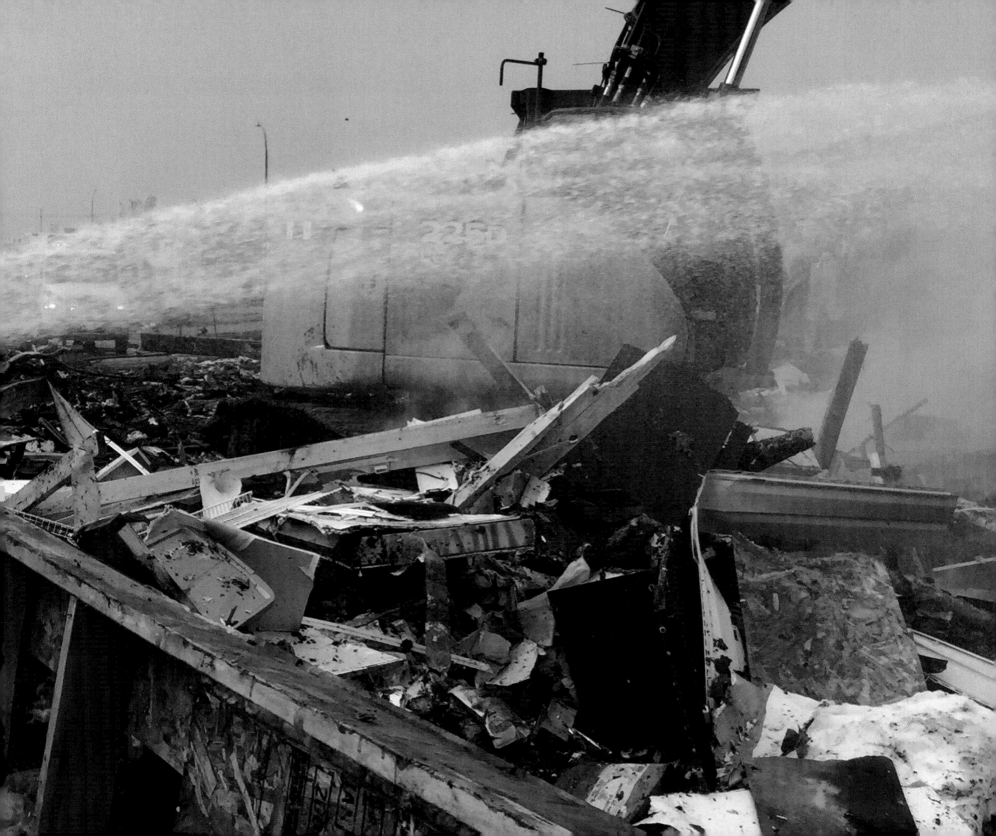

Minutes later we got word that a backhoe at the front of the fire had fallen into a basement — the only basement in a trailer park that I had heard of! A dozer operator and a new hoe operator came over to our truck. The boys gave them a quick lesson on how to work our air packs and the two operators made their way back into the fire. The dozer winched onto the hoe and pulled it out.

Later Duggan told me he had seen someone wandering around the scene. Dan was standing up on the pumper and yelled at me that there was somebody on the other side of the pump. I didn't have time to think, and went around the side of the pump, shoving the guy and yelling at him to get out of here. He was wide-eyed and just keeping his balance with each shove. On the third shove, I looked down and saw the letters RCMP on his vest. As soon as I saw that, I gave him a hug and apologized. After I told him the story, we were cool again and we shook hands with a laugh of relief.

As if enough hadn't happened on this call, a few minutes later an RCMP officer went running between the trailers with his gun drawn. Talking with them later, we discovered they were on the hunt for an arsonist. *Steve*

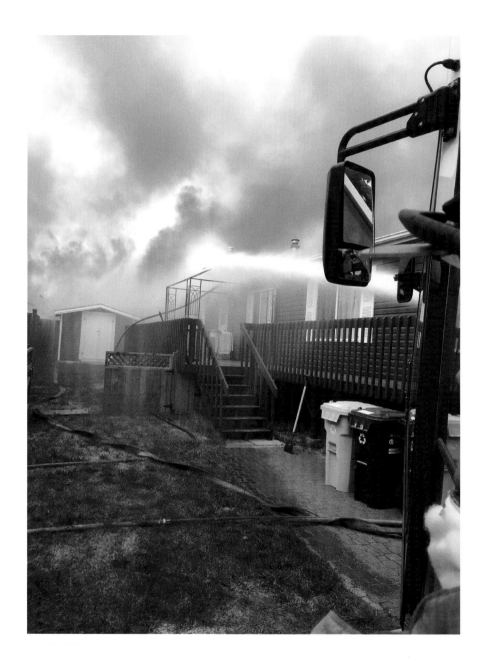

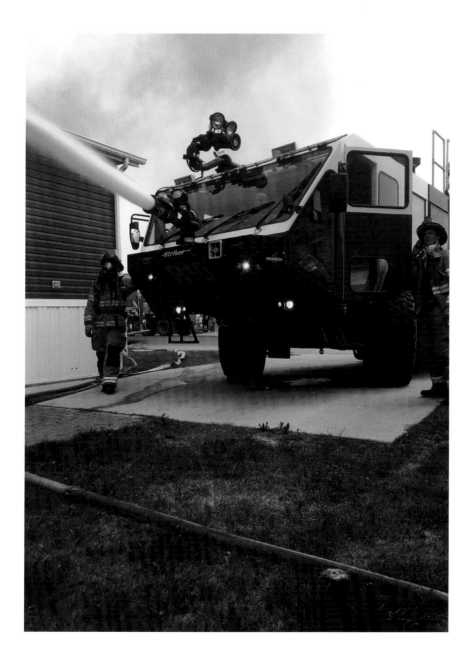

Crossfield Fire, the department from my hometown, was on the east end of the street dousing the fire with their aerial truck.

Later, when I came around the front of the trailer, I saw Hurley having a rest on the lawn. He pointed to a lady who was on top of my pump inserting the hose into my tank. "God bless that woman," he said. This lady was a tanker operator and hadn't left since the fire started. She was a smaller woman, packing a heavy hose to the top of the firetruck. She had been sleeping in her car at night. I went over and told her she was a beauty as I gave her a hug. I couldn't hold the tears back. It was incredible to see the people who were giving all they had for our community.

We repacked the truck and pulled around to the front of the street. We worked for a couple more hours overhauling the rubble. A new hoe showed up, to replace the one that had fallen in, and pulled the wreckage out while we soaked it down so it would never light up again. After we finished, a truck pulled up and dropped off a tub full of cooked steaks and all the fixings. We ate like kings. *Steve*

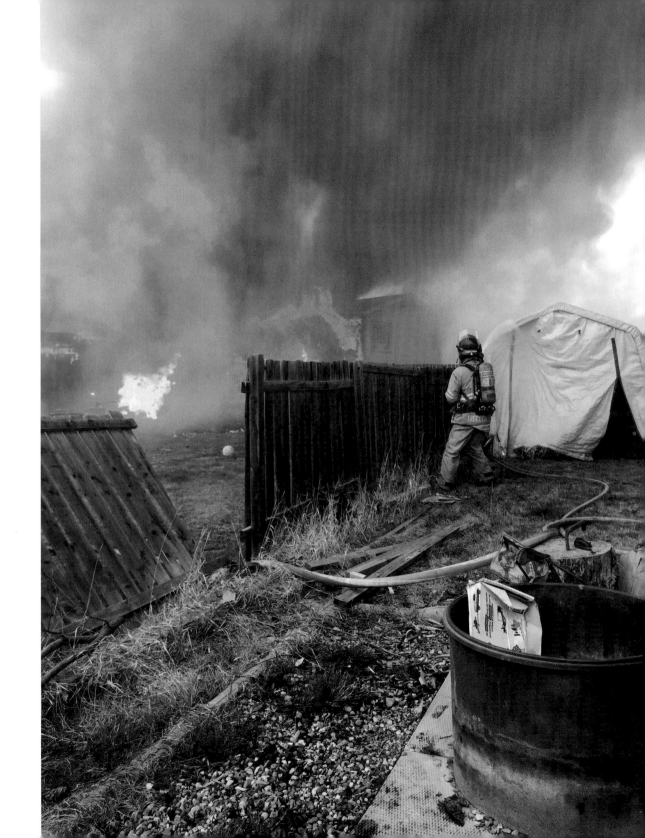

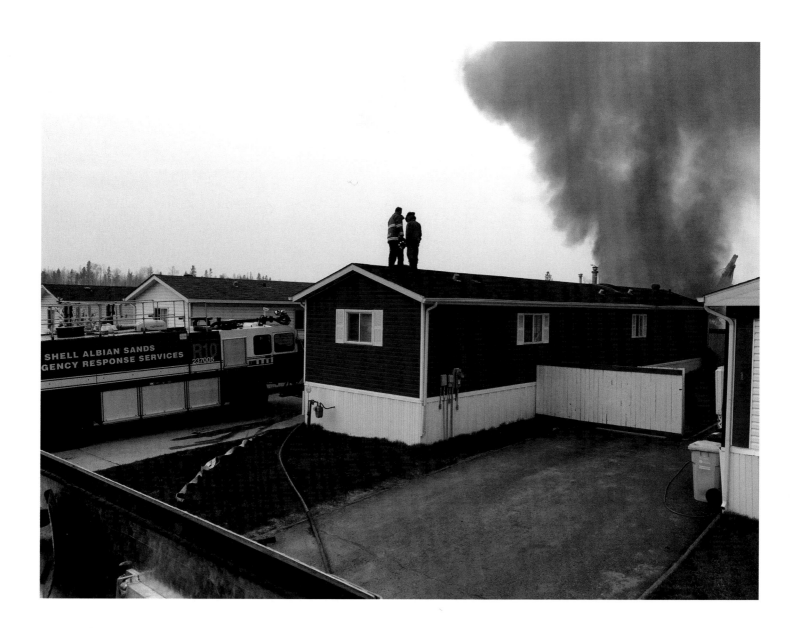

Once the smoke cleared, we loaded up the truck again. It was nice being able to put out a house fire from basically start to finish and not retreat a number of times. Another day had grown to night, and we were told that a local hotel north of the city had been made available for all first responders to reside in, with hot water and meals prepped fresh. As we made our way over, I couldn't wait to shower for the first time in five days and neither could any of the guys in our truck.

At the hotel we were greeted by other members of our department, some of whom we hadn't seen since the beginning of the fire and others who had been through some thick situations. All members were properly set up with their own rooms. I opened the door, stripped down, and couldn't get in that shower fast enough. The clear water pouring from the head of the shower turned to black as it entered the drain. I normally take things such as a shower for granted but it made me realize how lucky I was.

The fifth day was coming to an end, but it was the first night we could rest easy, knowing that other departments and resources were monitoring our city as we slept comfortably. We still weren't out of the fight but our minds were at ease. I made my nightly phone call to Carlene, to let her know I was safe and that things were starting to fall into place. The normal we were desperately searching for was on our horizon. *Jerron*

The chaos of the first few days had now subsided into a feeling of normality. Now and then a call would come in for a fire here and there but the big pressure was lifted and the out-of-town crews had really taken over for us and were giving us a break. Some of the crews went as far as deep-cleaning our fire hall so we wouldn't have to do it. They took good care of us and we appreciated it. We were mentally and physically exhausted. I don't think the scale of what we'd gone through had even registered yet in our minds. **Left to right:** Doug Noseworthy, Graham Hurley, Dan Letourneau, Cody Havens, Pat Duggan, Jerron Hawley, Steve Sackett, Adam Hiscock. *Steve*

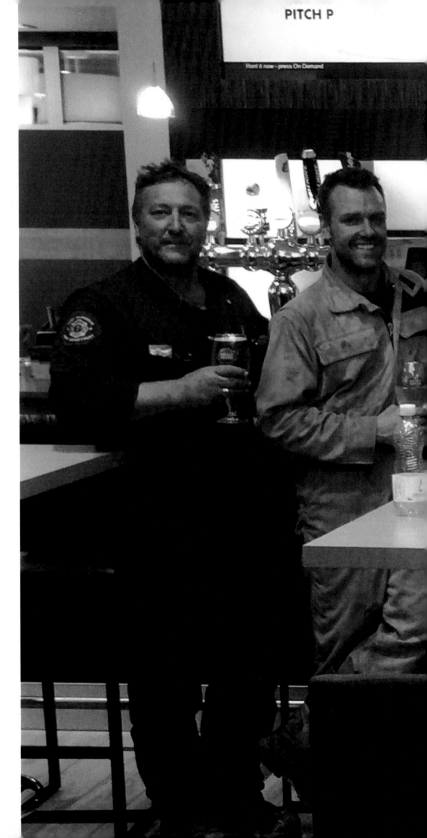

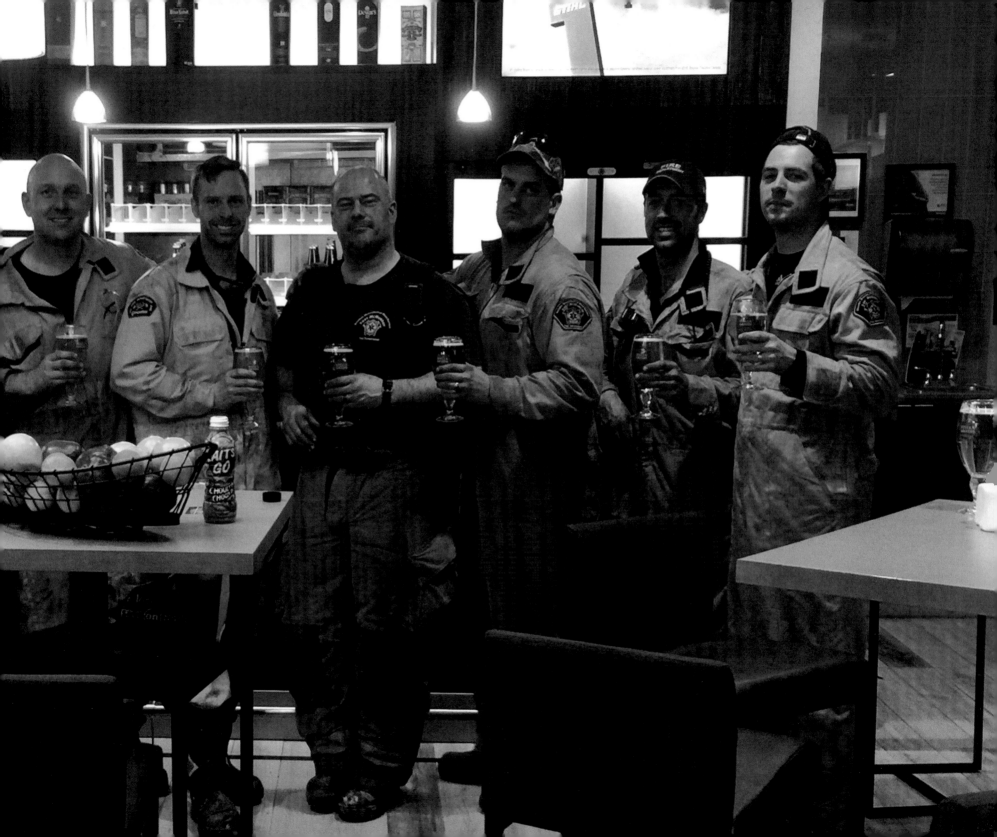

MAY 8
Going Home

Around this time, all of Fort McMurray's firefighters had been put up by the city in a hotel on the north end of town. Shifts were formed again, and we were put on a six-on, six-off rotation. Once my shift rotated to days off, I made my way south, straight to the farm for some R and R. My family had a welcome-back party for me, and I spent a couple of days on the tractor putting in the crop. I parked my dad's fifth-wheel camper at a campsite out west and began writing down my last couple of weeks of adventure. As I was writing, the camp owner stopped by my site and told me I hadn't paid my camping fees. I apologized and gave him my twenty dollars.

As he was filling out my camping permit, he asked where I was from. I told him Fort McMurray and that I was a firefighter up there. He handed back my twenty dollars and said tomorrow I was to move my trailer into his yard and set up with full power and water on the side of his dugout for no charge. His name was Scott, and the next day he helped me set up on his property on a beautiful little spot beside an old train caboose where his good friend lived. I got to know these two men well by the end of the six days, and it was a perfect place to relax and write down my story.

It felt strange to be away from Fort McMurray and back into normal life. There is a feeling of seclusion because no one else really understands what is going on in your head after an event like that. It can't be explained and no matter how hard you try, there is always a disconnect or an inability to get it across. —*Steve*

After my six days off, I drove the seven hours back to Fort McMurray. I was excited to go back, wondering what kind of adventure was coming my way. One morning, back in the hotel, I was woken by the sound of an explosion, which lightly rattled the window of my room. I thought maybe a propane bottle had blowied off somewhere in the trees. Minutes later there was a knock on my hotel room door and a voice said, "Get out of the hotel — there's been an explosion." I grouped up with a couple guys on my shift and we drove up to Hall 4 to get a briefing. There had been an explosion in Thickwood while C-shift was on and my shift was to relieve those boys and girls. On the drive to the explosion site, I realized the address was very close to the house of a friend of mine, Bob Barber. When we rounded the corner onto the street, I couldn't believe my eyes. Bob's house was nothing but a pile of debris. Bob has muscular dystrophy and is wheelchair-bound. I had done a lot of work at his house helping him out over the past few years, and we had become friends. I felt horrible that, in an area relatively untouched by the fire, his would be the house to explode. When Bob's house exploded from a buildup of natural gas igniting, it sent out a shockwave that damaged more than sixty homes and woke me up in my hotel three kilometres away. *Steve*

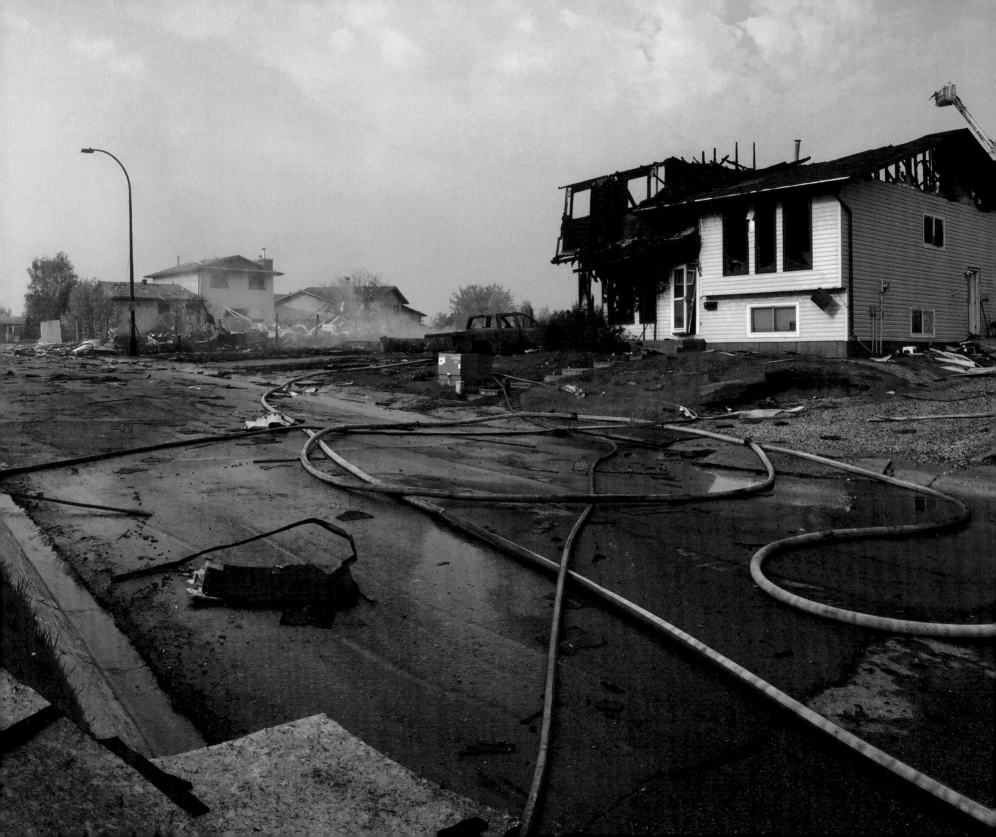

The city was still under serious threat but
things were calming down. We spent the
majority of that day driving around the
city. As we drove down our city's highways,
we looked in amazement at the trucks from
all over: Calgary, Edmonton, St. Albert,
Lac La Biche — so many I can't name them
all. These trucks were all in our city helping
us out when we needed them the most. I
knew I'd never see that many different city
trucks in one spot again. It was something
I'll never forget. *Jerron*

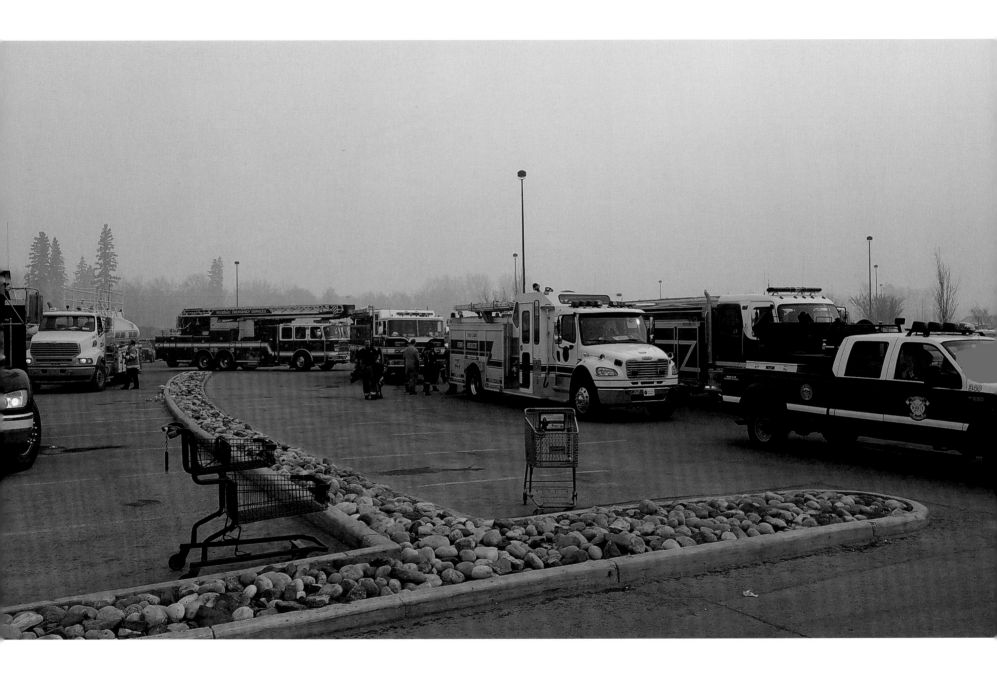

Duggan told us we needed to head to Thickwood, where all FMFD members were to gather. For the first time since the fire began, every member of our department was meeting. Self-assembled crews from our department arrived one by one. Ear-to-ear smiles were met with high fives and hugs. We settled in for the meeting. More than 120 members were standing strong. The group became silent for a moment, before someone spoke up and we erupted in cheers. I had never been more proud to be a part of this team. *Jerron*

We were told that we were going back to normal shift schedules the next day. We were getting back to our hall, back to our original crews, and we couldn't wait.

We had been salvaging tools and equipment in the preceding days. This is a photo of the mop Graham found and used to put out grass fires in Abasand. *Jerron*

The days went by smoothly. The city was still evacuated and essentially on lockdown, so we were basically told that once we'd finished our day or night to just stay at the hotel. If we were driving personal vehicles, you needed your FD ID and badge.

I had no problem navigating around the city on behalf of some fellow Capers who wanted reassurance their house was safe. (A lot of Capers work in Fort McMurray.) Being able to send a simple photo of a person's house to them was a minuscule effort considering the amount of stress they were feeling, worrying that they had lost everything.

I was beginning to plan my trip home to see my family, and every time I thought of seeing them, my heart would race. I had made a small request for when I arrived home: to have all immediate family along with in-laws meet at my parents' house. I didn't tell them what for but they had no problem planning it.

I shared a flight with two other members who were flying home to Ontario. I was connecting to a flight to Halifax, then driving home. On the plane, as the three of us listened to the typical flight safety instructions over the intercom, the flight attendant announced there were "three members of the Fort McMurray Fire Department on board." The whole cabin broke into an emotional cheer. I remember looking over at the two other fellas, and we had to give ourselves a big stern gut punch to hold back the tears. This was pretty much the first time we had seen any members of the public after we had spent two weeks in a city that was at a stop. This was our first taste of how the whole country was looking out for us.

I had to take a few drives up and down the road before I felt I was able to pull into my driveway. I knew it was going to be an emotional visit and that I had to pull it together to see my family. I saw my father peeking out the window as I was about to park. At the front porch, my eyes locked with Carlene's, the familiar beautiful brown eyes I normally wake up to every morning. Tears were on her cheeks as I walked through the door. I dropped my bags and hugged her. We didn't say many words besides the typical three of "I love you" — it was enough that we were together. I proceeded through the house and entered the kitchen where the rest of my family were waiting — Darcy, Lynette, Chantelle, Ardell, Loren, Lance, Dad, and Mum. One by one they lined up to give me a hug of relief. I'm home, I'm safe, we're all back safe. *Jerron*

Released. My shift was the first to have a significant amount of time off. We had four days. It was reckless to be driving so far on so little sleep over a week's worth of time. I looked outside and saw small flames in my backyard. I ran out to the tree line and stomped them out as best I could. There were pumper trucks in the area, and I figured if anything flared up they would catch it. Nothing mattered to me right then but seeing my family.

I got in the truck and drove. A pumper crew was fighting fire on Highway 69 towards the city. I felt guilty on some level for leaving. As I turned south on Highway 63, there were still more fire crews fighting fire. In my rear-view mirror, I could see a black smudge over a navy blue night with orange glows nearest the horizon. I kept driving. It was amazing how awake I felt. I had a mission to complete. The highway was desolate. I had never seen it so empty for so long. I was about ninety kilometres outside of Fort McMurray when my emotions finally caught up to me. I felt my jaw drop, I remember whispering, "Oh my god" to myself, and I wept. What had happened? The things I had seen and done. Was it even real? The pain in my chest, the tears streaming down my face were proof that it was.

I remember speeding during this time. I couldn't call Sarah, my phone was broken. This trip was going to be for me and me alone. I thought back to growing up in Fort McMurray: of the streets where I'd played as a kid, the same ones I partied on as a teenager, did 9-1-1 calls on, when I became an EMT. They were now the same ones I had watched burn to the ground. It was a lot to take in and I finally let it all go. I have had many epic drives on this highway but I will never forget this one. I didn't even know the address of where Sarah was staying in Calgary, just a vague idea of which neighbourhood. I stopped at Wandering River (two hundred kilometres south) for gas. I hopped back into the truck and drove and didn't stop. I was racing the rising sun to the south of Alberta. But eventually, after eight or so hours of driving, I found a door to knock on and a beautiful woman walked outside and I had a question to ask her that I already knew the answer to. *Graham*

I spent a total of ten days home in Port Hood, Cape Breton, before heading back to Fort McMurray and returning to work. My first day shift was on May 31 with June 1 being the first day of the re-entry to the city. It was a bittersweet feeling, leaving my family back east while joining my other brothers and sisters of FMFD as we prepared to welcome back the citizens of Fort McMurray. In the short time I was gone, the ash-covered ground had already started to be filled in by green grass and shrubs poking through. Over the next few days more designated areas opened up, allowing more of the city's residents to return home. Once again, it was time to shine light on the positives.

We were celebrating our accomplishments not just from the point of view of emergency services, but because the people of Fort McMurray who had been forced to drop everything within a matter of minutes and leave it all behind, taking nothing but the most important things with them, their families, had survived. We were celebrating the people along Highway 63, rushing out to the highways with fuel and food to help in any way possible, the cities of Alberta from Edmonton to Calgary accommodating a tenth of their populations overnight, then sending up units of their emergency response teams to join the attack. We were celebrating the provinces from west to east donating millions upon millions of dollars to the Red Cross and the efforts of countless Canadians who staged everything from benefit concerts to lemonade stands. Canada was put on hold for those few horrific days — everyone who had a television set or access to social media was glued to what was happening and had one reaction: to help.

As each day passes, everyday life falls back into place, returning to normal. Lineups at Tim Hortons returned, impatient drivers at the long red lights and the black ghost photo radar trucks appear on the side of the roads as people curse driving past the flash. When people look back on this event, they need not look at the photos and videos of the fire destroying homes and forests but at how, when people were in need, differences were dropped, the little things were put aside, and selfishness was nonexistent. Carlene and I are now blessed to have our first child. He is a citizen of Fort McMurray, the city that brought a whole nation together.

Jerron

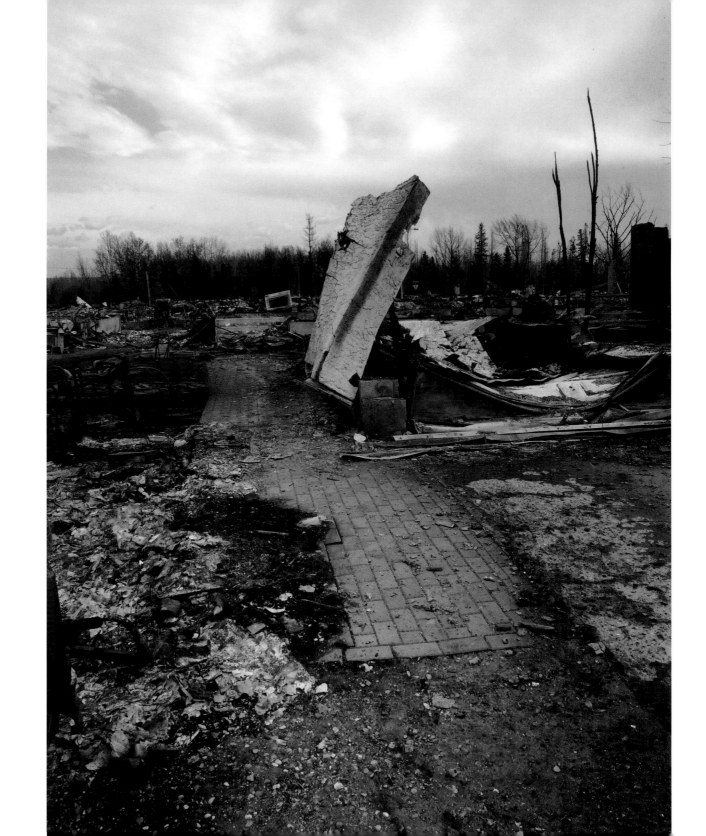

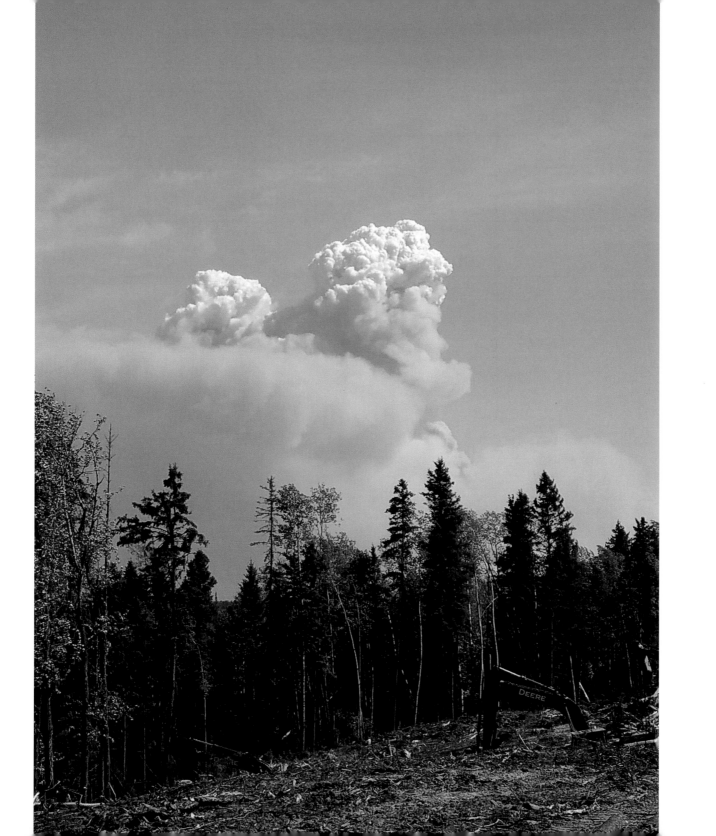

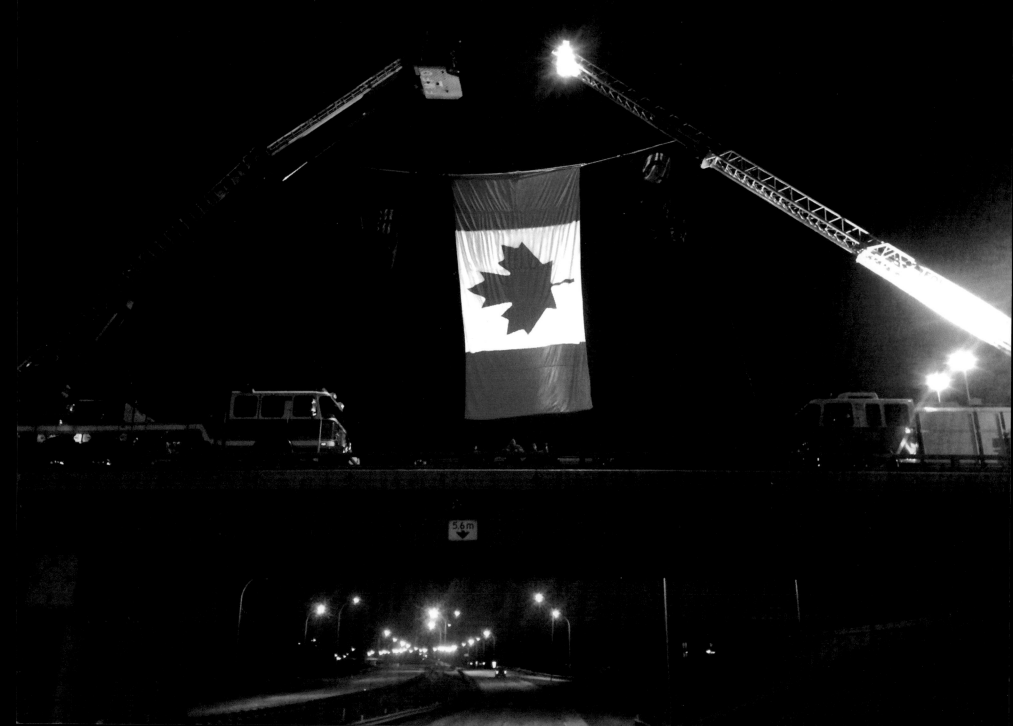

After returning to Fort McMurray from my second set of days off, we were told that some of the citizens of Fort McMurray were being allowed to return to their homes. That morning we set up our Bronto truck and our ladder truck on the overpass coming into town. We strung a huge Canadian flag between the two trucks and stood under the flag waving to all the vehicles returning to town. It was an incredible feeling. The people had watched us going in to fight the fire when they were leaving the town, and here we were welcoming them home. People honked their horns and waved frantically at us, and we later had a lot of feedback on how emotional it was for them to see us waving from the bridge. We stayed on the overpass taking shifts for a couple of weeks, hoping to wave at every single person who came back.

There was a great feeling of closure standing on the bridge. To me it marked the end and it felt like the battle was officially over. The hard, long-drawn-out process of rebuilding was up next but the major battle, our battle, was now over.

Fighting this fire instilled in me a great sense of pride. I have more pride in the community, this province, and this country than ever before. Good people put everything they had into protecting this community even if it wasn't their own. People from all over the country and even the world sent their best wishes and did what they could to help. The human spirit is still alive and well and shows its best side when it's needed the most.

This fire was at a scale that I will likely never see again. I am proud of my brothers and sisters in the department and I sleep easy knowing I did everything I could and gave it my all. The strengthening of brotherhood and friendships that were formed during this event will last a lifetime. *Steve*

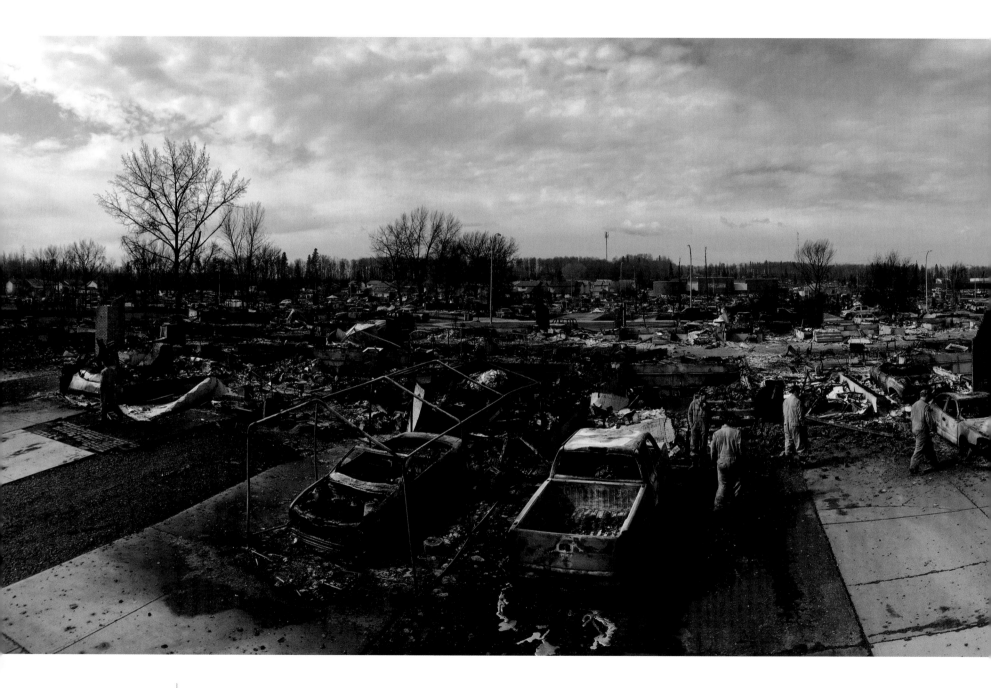

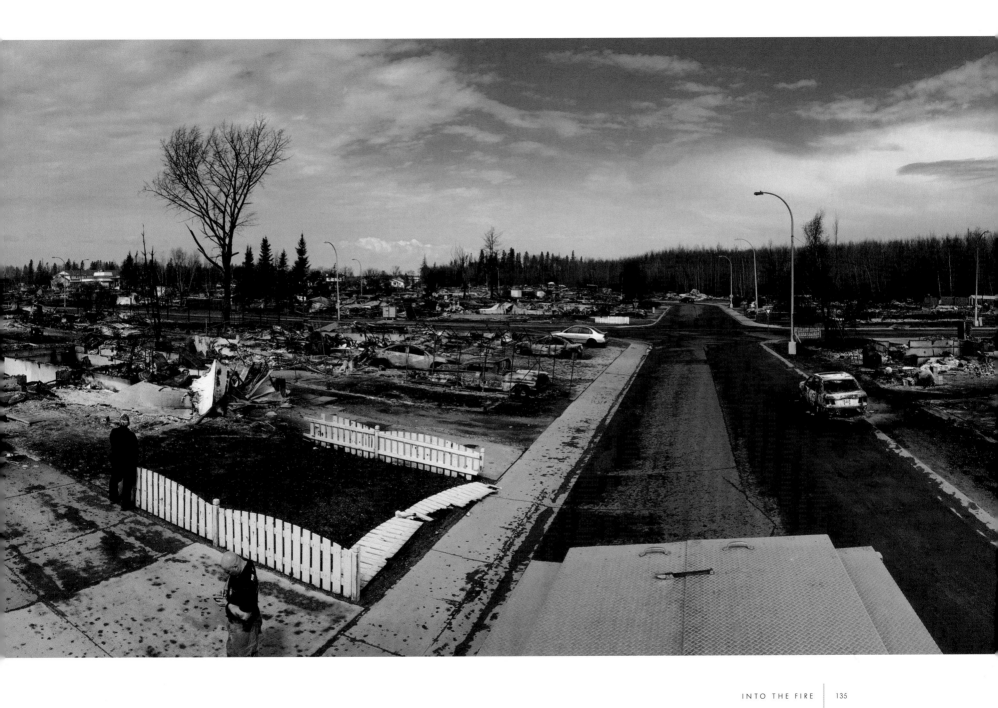

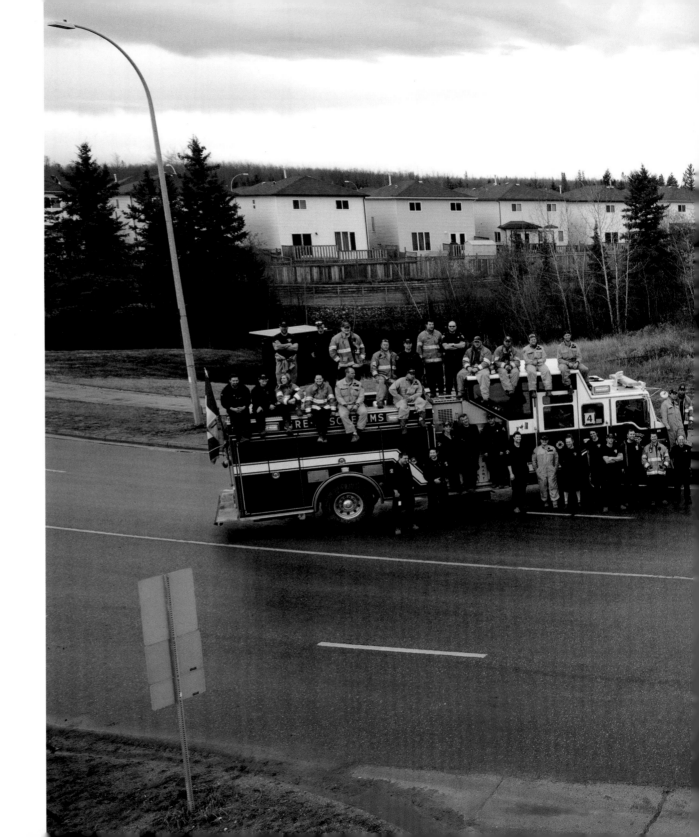

Fort McMurray Fire Department,
Mother's Day, May 8, 2016

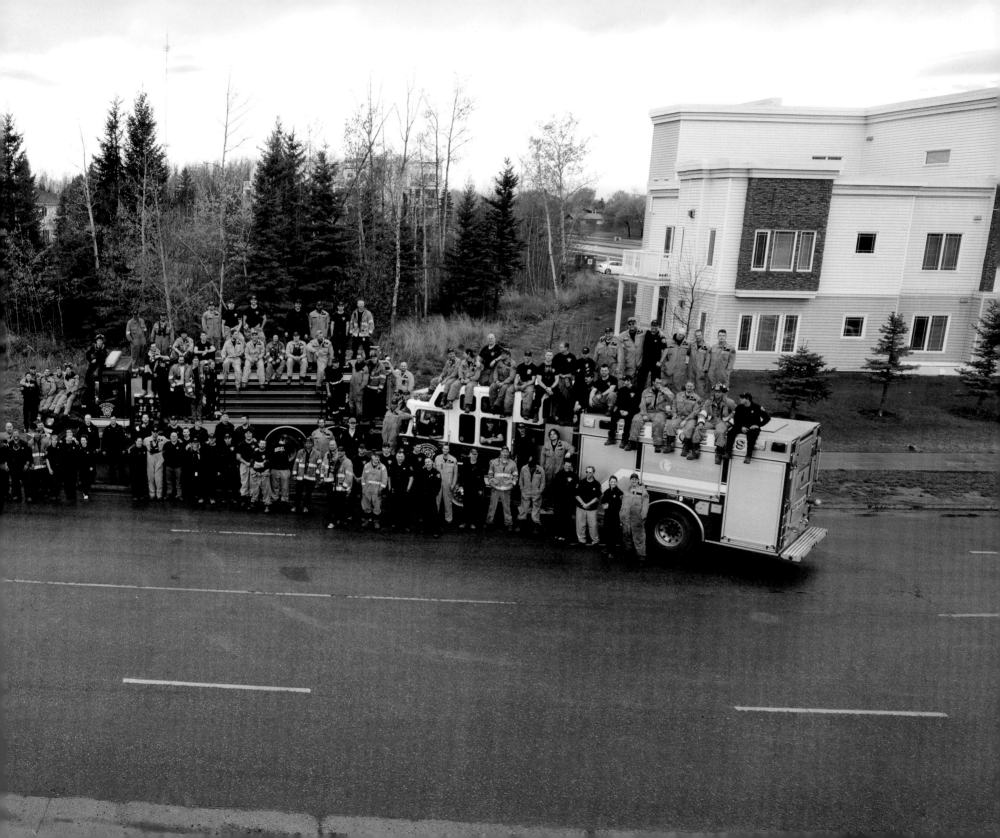

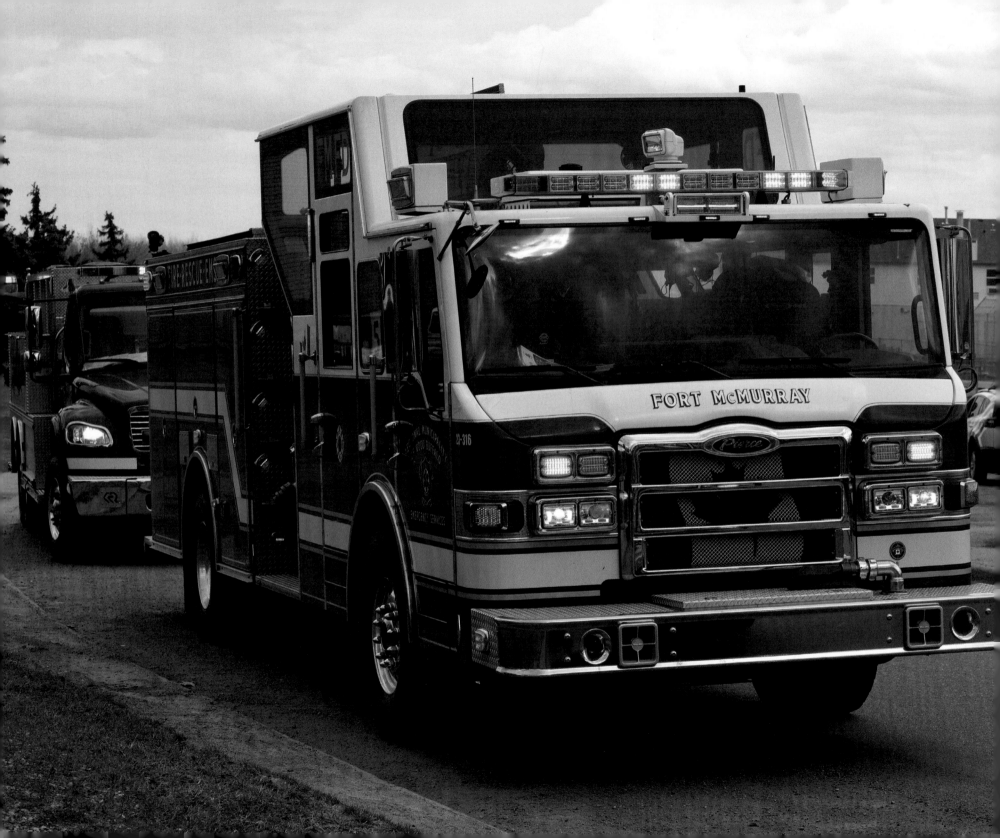

Epilogue

Fire can't destroy memories. Fire can turn your belongings to ashes, but it can't destroy what they meant to you. The battle for Fort McMurray is just beginning. There is an entire community to rebuild. Our FMFD family – including all those who stayed and those who came for the fight – fought like lions. There were long days away from family, away from familiar comforts, which were physically, emotionally, and mentally challenging. But now we remember why we are here, and the opportunity we have been given. We have a chance to rebuild and define our city anew. Everyday actions help to make new memories for our children, to give them a true sense of home. Out of ashes and ruins shall rise new buildings but also a new sense of identity and community for the citizens of Fort McMurray.

About the Authors

JERRON HAWLEY was born in Port Hood, Nova Scotia, and is the youngest of seven children. After enrolling in the Nova Scotia Firefighter School Program in 2011, he moved to Fort McMurray, joining the Fort McMurray Fire Department. He and his wife, Carlene, live in Fort McMurray with their son, Maverick, and their golden retriever, Gally.

GRAHAM HURLEY grew up in Beacon Hill in Fort McMurray. After serving with the Canadian Armed Forces, with a deployment to Afghanistan, he trained to become a firefighter and joined the Fort McMurray Fire Department in 2013. He lives in Fort McMurray with his fiancé, Sarah Macdonald, and daughter, Ava.

STEVE SACKETT grew up on a family farm, just north of Calgary, Alberta. Steve began volunteering as a firefighter at the age of 17. After finishing a diploma in heavy duty mechanics, he completed his Emergency Medical Technician certificate and was hired as a Firefighter/EMT in 2009.

Left to right: Graham Hurley, Jerron Hawley, Steve Sackett.

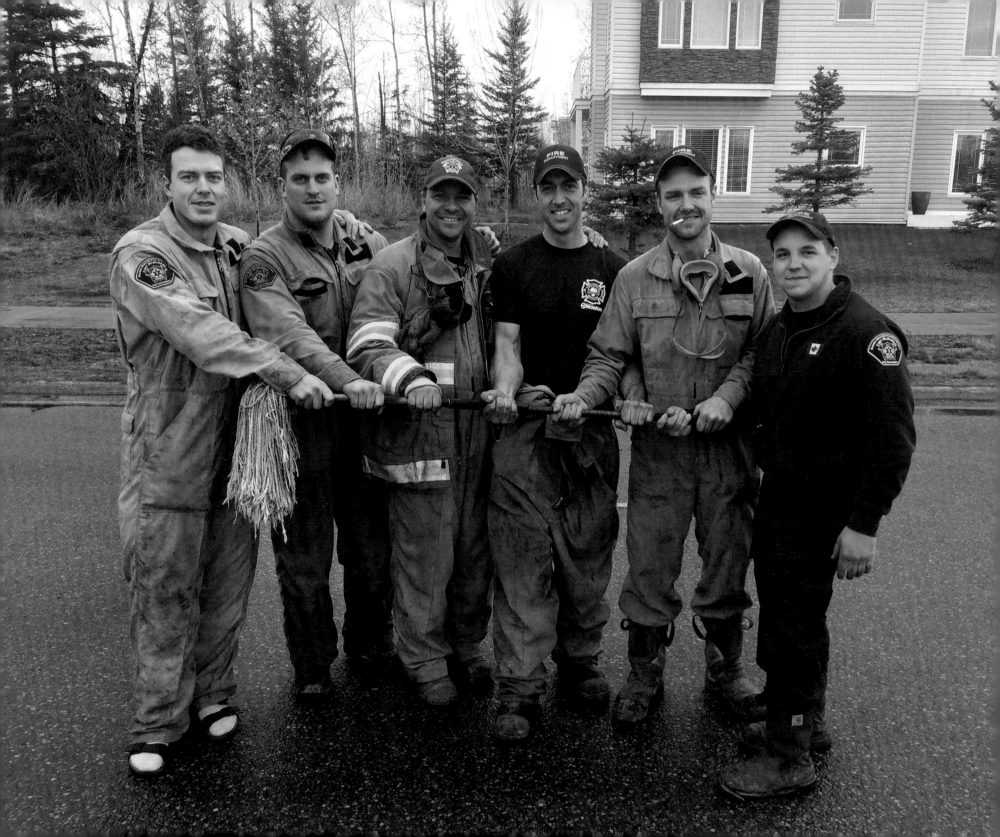

Acknowledgements

To the citizens of Fort McMurray, who helped each other evacuate the city quickly and safely:
we could not have done it without you. It has been and continues to be an honour to serve you.

Left to right: Jonathan Bruggeling, Jerron Hawley, Dave Tovey, Steve Sackett, Graham Hurley, Adam Chrapko.

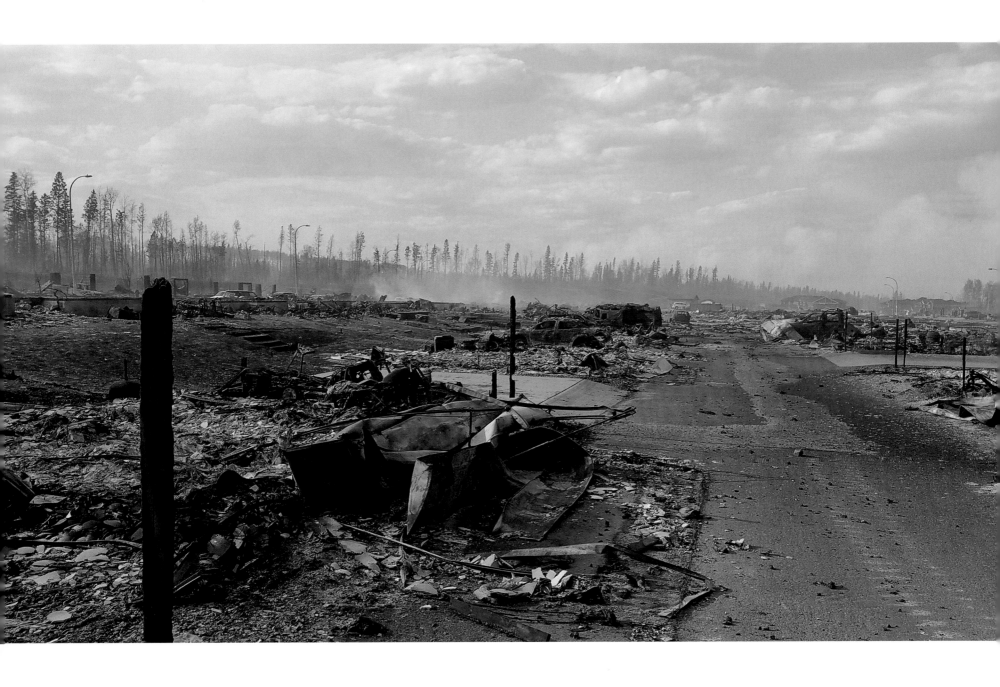

Photo Credits

Jerron Hawley: pages ii-iii, xii, 8, 9, 24, 29, 36, 42, 59, 60, 64, 68, 72, 76, 78, 80, 82, 83, 90, 92, 94, 95, 98, 102, 103, 104-105, 106, 107, 109, 112-113, 118, 122, 124, 126, 127, 130, 134-135, 142, 143

Graham Hurley: pages 28, 100

Doug Noseworthy: pages 30, 38, 56, 100

Troy Palmer: pages vi, viii, 3, 5, 6, 11, 12, 17, 18, 20-21, 26-27, 32-33, 34-35, 41, 43, 44, 46-47, 49, 50, 52-53, 55, 63, 66-67, 71, 74-75, 81, 84, 85, 86, 88-89, 93, 96-97, 110, 114, 119, 120, 123, 128-129, 131, 136-137, 138-139, 140, 146

Steve Sackett: pages i, 14-15, 22-23, 108, 116-117, 132, 144

The Fort McMurray wildfire, which entered the city on May 3, 2016, was declared under control on July 4. The evacuation of approximately 88,000 citizens lasted until June 1, and many did not return until months later. In 2017, it was estimated that the total cost of the wildfire will exceed $8.86 billion. As of this writing, more than 160 homes are under construction, and a building boom is expected in the spring of 2017.

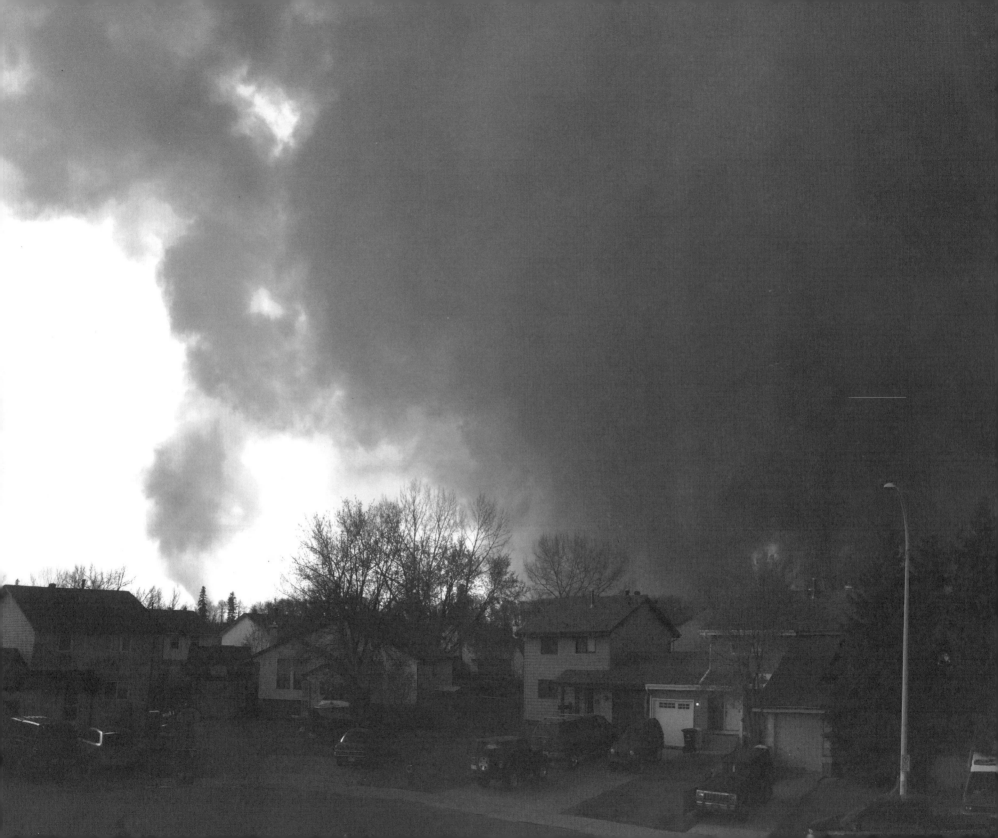